I'm so pleased you looked up this part
of the family. Thanks for coming to see us.
Betty Rahins
May 2012

Battle Creek

D0764916

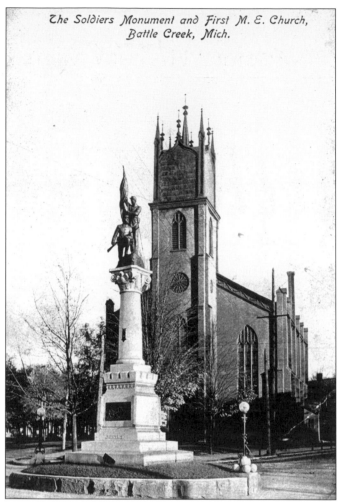

The Soldiers Monument and First M. E. Church, Battle Creek, Mich.

The Battle Creek First United Methodist Church was dedicated on the pie-shaped corner of the intersection of Division Street, Marshall Street (now East Michigan Avenue), Main Street, and South Avenue in 1860. With the 1901 construction of the Soldiers and Sailors Monument, the area became known as Monument Square. The church was demolished in 1907 to make way for the present church that was dedicated in 1908 (see page 111). (Courtesy of the Frances Thornton Battle Creek Collection.)

On the front cover: The Battle Creek Sanitarium's float, from the City of Battle Creek Centennial Parade in 1931, features some of the many breakfast products that were available from the "San" to the health-conscious public around the world and proudly states, "What we eat today, walks and talks tomorrow." (Courtesy of the Frances Thornton Battle Creek Collection.)

On the back cover: This is a souvenir card of Battle Creek. This image using stylized lettering features pictures of various city scenes, including the Post Factory, Percy Jones Hospital (now the Hart, Dole, Inouye Federal Center), a United States post office (now Commerce Pointe), Southeastern Junior High School (now South Hill Academy), Community Hospital, W. K. Kellogg Junior High School and Auditorium, Goguac Lake, First United Methodist Church, and the Youth Building (now the Village in Irving Park). (Courtesy of the Frances Thornton Battle Creek Collection.)

POSTCARD HISTORY SERIES

Battle Creek

Carol Bennett and Kurt Thornton

ARCADIA
PUBLISHING

Published by Arcadia Publishing
Charleston SC, Chicago IL, Portsmouth NH, San Francisco CA

Printed in the United States of America

Library of Congress Control Number: 2009928787

For all general information contact Arcadia Publishing at:
Telephone 843-853-2070
Fax 843-853-0044
E-mail sales@arcadiapublishing.com
For customer service and orders:
Toll-Free 1-888-313-2665

Visit us on the Internet at www.arcadiapublishing.com

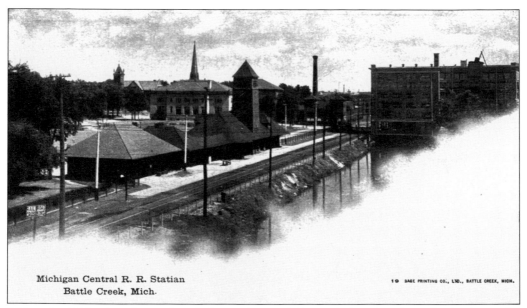

Michigan Central R. R. Statian
Battle Creek, Mich.

1 9 SAGE PRINTING CO., LTD., BATTLE CREEK, MICH.

This early-1900s view shows, from left to right, St. Philip Catholic Church, Willard Library, the spire of St. Thomas Episcopal Church, the American Steam Pump Factory, the Ward Building, and, in the foreground, the Michigan Central Railroad Station (now the restaurant Clara's on the River).

CONTENTS

ACKNOWLEDGMENTS

Coauthor Kurt Thornton would like to thank the following for their assistance with this book: Martin Ashley; the Battle Creek Historic District Commission *Walking Tour Brochures*; Carol Bennett, my coauthor; Ann and Al Bobrofsky; Michael Breitbach; *C. O. Brown Stadium Dedication Program, July 4, 1990*; John Buchmeier; Diane and Mike Buckley; Mary Butler; my Calhoun County Circuit Court coworkers (you are great); Cameron Carson; Ken Clark; Ross H. Coller Collection; Fred Cummins, *Still on the Beat-History of Battle Creek Police Department*; Alex Fisher; Michael Gregory, *The Forgotten Years of Battle Creek*; Myra Heald; Heritage, *Gold-in-Flakes*; Battle Creek Journal's *50th Anniversary Book*; the *1962 Kellogg Community College Dedication Program*; MaryAnne Kidney; Susan Lampas; George Livingston; Berenice Bryant Lowe; Larry Massie and Peter Schmit, *Battle Creek: The Place Behind the Product*; Art Middleton, *This was Battle Creek*; Jim Middleton; Anne Norlander; Chris Paul; Jane Ratner; *Religious Heritage-Greater Battle Creek Churches:1832-1976*; friends at Riverside Café in Bellevue; Ellsworth Willis Roberts; Paul Robbins; Susie Savio; Amy South; Marlene Steele; Joyce and Duff Stolz; Kathy Thornton; Junior Thornton, for marrying the prettiest girl there was; the Willard Library Local History Collection; and Anna Wilson, our understanding and patient editor at Arcadia Publishing.

A special thanks goes to my mother, Frances Thornton. She loved Battle Creek and passed those feelings on to her children. Without her years of devotion to her family and Battle Creek history, you would be looking at blank pages.

Along with those mentioned above, coauthor Carol Bennett would like to thank her family and her father, Paul Linstead Jr., for instilling the desire to learn and enjoy the place she lives.

Unless otherwise noted, all images appear courtesy of the Frances Thornton Battle Creek Collection.

INTRODUCTION

The settlement eventually known as Battle Creek was founded in 1831 when a group of pioneer entrepreneurs chose the confluence of the Kalamazoo and Battle Creek Rivers as a location for their venture. Robert Clark, John J. Guernsey, Lucius Lyon, and Sands McCamly had all purchased land at the site, but to get controlling interest, McCamly purchased Clark's and Lyon's options on the property for $100 each. Guernsey sold his interest to Nathaniel Barney, an innkeeper. Barney built his first local inn, Barney's Tavern, on the northwest riverbank near the area where the rivers came together (now the site of the closed Kellogg's Cereal City USA).

In 1835, McCamly hired men who had worked at digging the Erie Canal in New York State and local Native Americans to dig a one-and-a-quarter-mile-long millrace between the two rivers. The millrace used the two-foot drop between the rivers to move the rushing water (that is why it is called a millrace) to move the water wheels that powered the mills along the race.

The mills prospered and the community grew. The Michigan Central Railroad was extended to the village in 1845, making transportation of people and manufactured goods a financial boom to the city. Factories sprang up, and the city's location between Detroit and Chicago contributed to making the area a financial success.

The name of Battle Creek was officially chosen for the city on December 31, 1858, when the citizens voted to become incorporated. Along with choosing incorporation, a choice on the ballet for naming the new city was up for vote. Among the possible names and number of votes cast for each choice were Peninsular City (9 votes), Wopokisco (50 votes), Calhoun City (93 votes), or Battle Creek (315 votes). On February 3, 1859, Battle Creek was officially a city, signed into law by Michigan governor Moses Wisner. The new city's first election was held on March 7, 1859, where its first mayor, Elijah Pendill, a 47-year-old dairyman, temperance advocate, and Republican, was elected along with a city council.

Toward the end of the 19th century, Battle Creek was becoming nationally famous with its production of threshing machines, steam pumps, and printing presses. What really put Battle Creek on the map had its beginnings in 1861 when the Seventh Day Adventist Church moved its headquarters to the city and with them, the health reform movement. In 1894, a small accident occurred that profoundly changed the city (and the world). An experiment being performed at the Seventh Day Adventist–administered Battle Creek Sanitarium went awry. Dr. John Harvey Kellogg and his brother Will Keith Kellogg left some of their research unfinished overnight. The resulting mistake created the process for making flaked cereal. By 1902, over 40 companies were manufacturing cereal within the city limits, attempting to capitalize on the city's fame as the "Health Capital of the Midwest" to sell their product.

About this time, rapid color printing was becoming cheap and an easy way to advertise a product, a community, an idea, or a person. That along with the perfection of cheap efficient postal service led to the successful industry of souvenir postcards. Railroad service had long since made it easy to travel almost anywhere in the country, and people wanted to send messages to friends and family members that not only passed on the message but could show the wonderful sites being visited. Battle Creek had no shortage of such sites.

My mother, Frances Thornton, loved Battle Creek and was an avid collector of its history. When she was young, she began accumulating local postcards because they were cheap to attain and easy to store. As I grew up, I also enjoyed looking at the images and learning about this wonderful city's history. At that time (the late 1960s and early 1970s) there were very few illustrated local history books and virtually no video tapes, DVDs, or computer search engines that could show you the rich heritage of this community. By the time I was in junior high school, I accompanied mom to garage sales, flea markets, antique auctions, and anywhere else we might find a postcard we had never seen before. When I was in high school, she had created a network of friends, antique dealers, and even the local Battle Creek gas repairman who would trade cards and other historic items at our dining room table. Not only did I get to see many images of historic Battle Creek, but also I listened to the stories told by many of her "heritage dealers and authors," who included John Buchmeier (*History of the Battle Creek Federal Center*), Mary Butler (*Heritage Magazine*), and Berenice Lowe (*Tales of Battle Creek*). I acquired a lot of local history at my mother's side. As I said in my first book, *Battle Creek*, in the Images of America series produced by Arcadia Publishing, our house on Webber Street may not have been an archival repository, but I would be hard-pressed to say that mom's collection was not thorough. The Frances Thornton Collection of Battle Creek postcards became one of the largest in the country. It has been a wonderful resource for this and my other Arcadia books.

We did the best we could researching information about the images we are displaying. We apologize for any errors and welcome comments and/or corrections so we can get it right in the future.

—Kurt Thornton

Coauthors Kurt Thornton and Carol Bennett are surrounded by some of the thousands of postcards they had fun sorting through for this book.

One

BUSINESS, BREAKFAST, AND INDUSTRY

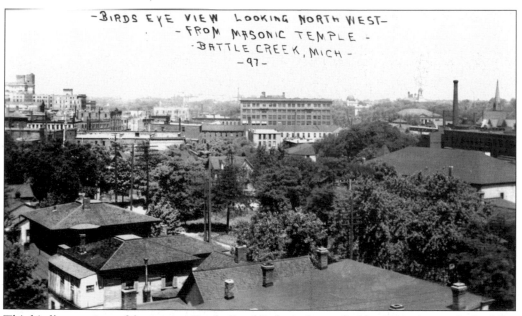

This bird's-eye view of downtown Battle Creek is from the roof of the Masonic temple, looking west. The image from the second decade of the 20th century shows, from left to right, the Post Building, the Post Tavern, the Battle Creek Sanitarium, the Ward Building, Battle Creek High School, old No. 1 school, Willard Library, and the spire of St. Thomas Episcopal Church. (Courtesy of Carol Bennett.)

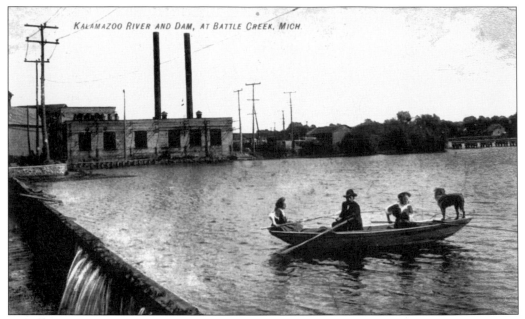

One of Battle Creek's founders, Sands McCamly, chose the site for the future city because of the two-foot drop between the Kalamazoo and Battle Creek Rivers. To increase the power of the water's flow in the 40-foot-wide millrace he had created, he constructed this dam. The water collected behind the dam became the millpond, shown here near Riverside Drive. Mills were the area's first industries.

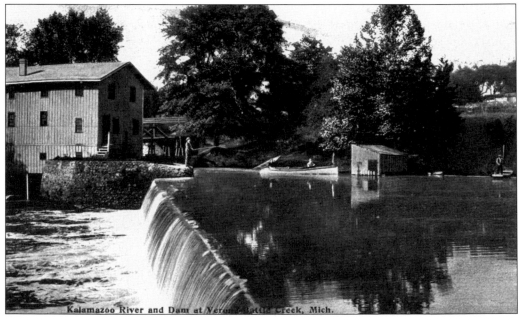

Ezra Convis was another early settler in the area. He envisioned a community called Verona, a few miles northeast of the Battle Creek settlement. To get industry started, the Verona Dam was constructed on the Battle Creek River (the postcard mistakenly calls it the Kalamazoo River) near Emmett Street. Convis was killed in a sleighing accident near Detroit, ending the dream of the city of Verona.

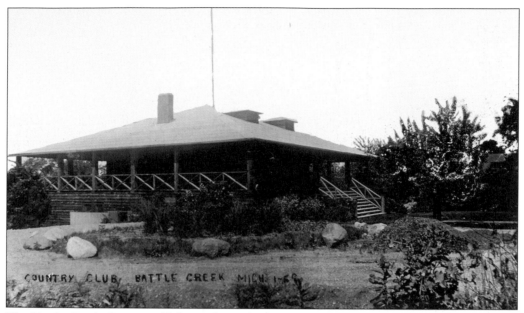

The Battle Creek Country Club was located on West Michigan Avenue near the Kalamazoo River; this was the organization's second location. For social gatherings, this clubhouse was built across the road from the country club's golf course (now the site of the present Leila Arboretum). According to the *Battle Creek Moon Journal*, the wide veranda was "a delightful spot to spend a hot summer day." In 1919, the country club moved to its present site, on the southeast shore of Goguac Lake.

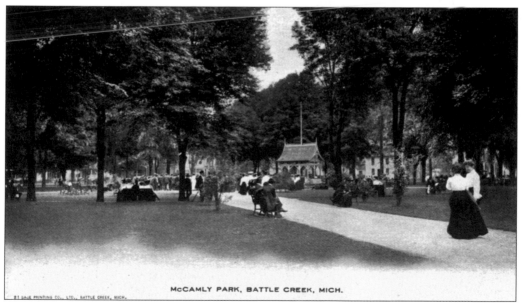

McCAMLY PARK, BATTLE CREEK, MICH.

On May 31, 1880, McCamly Park became the official name of the village's central square. The area had been set aside in the original plat for the community by Sands McCamly in the 1830s. In 1905, a Native American statue (known locally as Hobb's Indian) was located in the park's fountain. The statue was moved to Irving Park in 1965 to make room for the Soldiers and Sailors Monument that was moved from downtown.

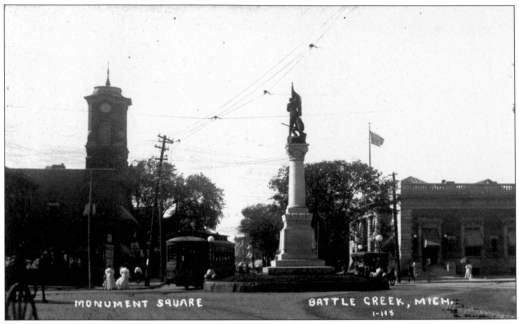

Monument Square, located at the intersection of Division Street, Marshall Street (now East Michigan Avenue), Main Street, and South Avenue, was considered the center of town for nearly 50 years. The square's name came from the Soldiers and Sailors Monument that was dedicated on March 3, 1901. The monument was the dream of Frank Kellogg (not connected with the cereal industry), who helped raise the $6,500 to pay for the memorial. The monument was moved to McCamly Park in 1966. Battle Creek installed electric lighting in 1884. Originally the lights were carbon arc electric lights. These two early-1900s views show the square proudly displaying the modern public lighting. The buildings are, from left to right, the Bromberg Jewelry Store (in the nighttime view), the First Baptist Church, the Soldiers and Sailors Monument, and the U.S. post office. (Above courtesy of Carol Bennett.)

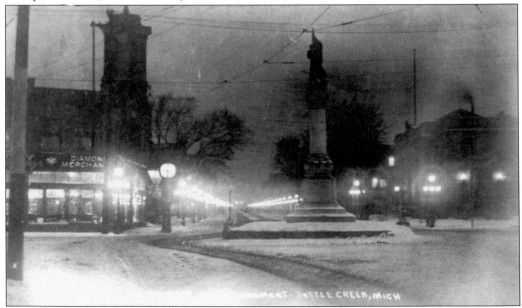

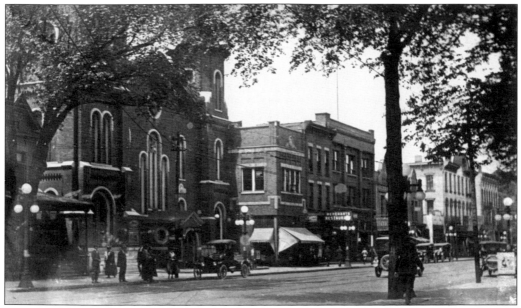

This early-1900s view of the south side of Main Street (now East Michigan Avenue) near Monument Square shows, from left to right, the First Baptist Church Parsonage, the First Baptist Church, Club Rooms, the Merchant's Restaurant, and "Hotel Row."

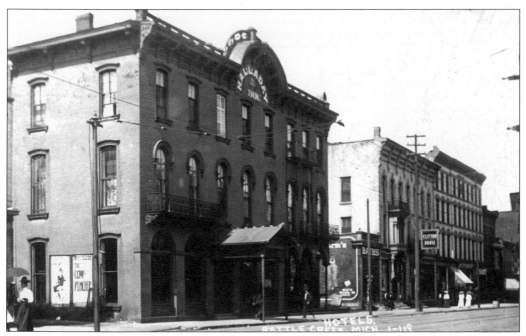

The Haladay Inn was originally built in 1865 as a 40-bed hotel called the Bristol House. In 1891, the name was changed to the Bidwell House, and in 1894, John F. Haladay renamed the hotel. It was demolished in 1947. The Clifton House was originally the Williams House Hotel, which opened on December 15, 1880. It combined with the Potter Block Building (on the far right) in 1887 and became the Clifton House in 1904. The 150-room hotel became the New Williams House in 1945.

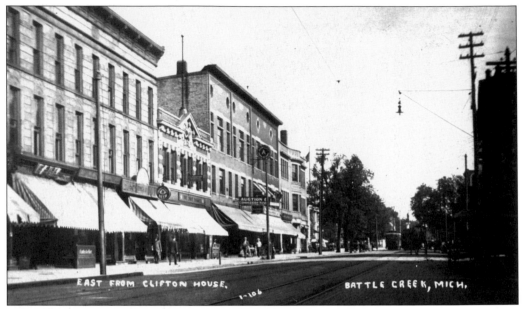

The north side of Main Street (now East Michigan Avenue) is shown in this early-1900s view. The buildings are, from left to right, the Anheuser Busch Building (the two-story building), the Boos block, and the YMCA building (opened in 1902 and used until 1912). Some of the businesses in the picture are Wakerman Insurance, Boos Billiard Parlor, the Shoe Market, and the Auction and Commission House.

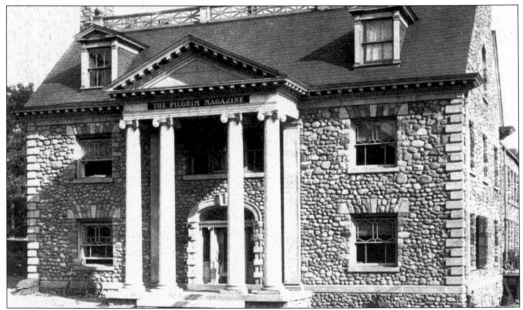

The Pilgrim Magazine Building at 18 Tompkins Street, constructed in 1915, was the home of many of the city's early newspapers. On June 7, 1915, the *Daily Moon* bought the *Battle Creek Journal* and became the *Moon Journal.* On September 1, 1918, the *Morning Enquirer* and the *Evening News* were combined to form the *Enquirer and News.* On February 14, 1940, the *Moon Journal* was acquired by the *Enquirer and News.* In 1951, a new *Enquirer and News* building was constructed on the corner of Van Buren and Tompkins Streets.

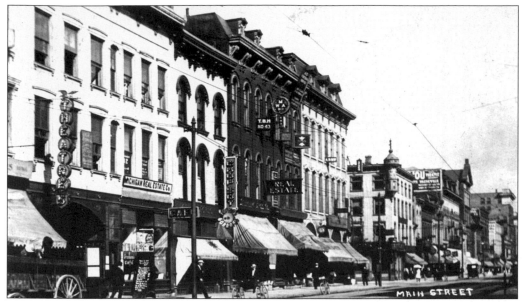

This early-1900s view of the south side of Main Street (now East Michigan Avenue) looking west, toward the intersection of Jefferson Street (now Capital Avenue), shows the thriving small businesses, among them the Rex Theatre (which eventually became the Strand Movie Theater), Grahams Café, the Chop Soy Restaurant, and Michigan Real Estate Company. This section of buildings was demolished in the late 1980s to make way for Millrace Park.

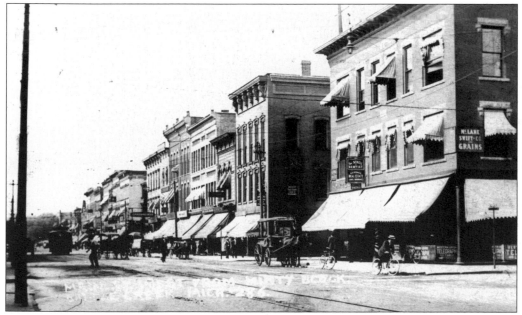

On the north side of Main Street (now East Michigan Avenue) looking west toward the Jefferson Street (now Capital Avenue) intersection, this early-1900s view shows, from left to right, Oppenheimers Store, the Amburg and Murphy Drug Store, the Boos-Basso block (the building opened in 1904 and housed the first store in the city to use paper bags), Queen City Real Estate, the intersection of Madison Street, Dr. Schell Dentist, Vernon Real Estate, and on the corner of Monroe Street, the Western Union Telegraph Office.

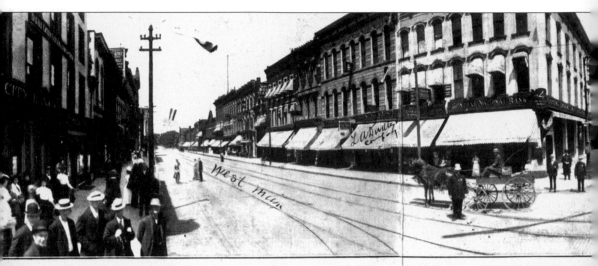

This three-fold card shows the intersection of Main Street (now Michigan Avenue) and Jefferson Street (now Capital Avenue NE) looking north, in the early 1900s. The area was known as the "Bank Corners" because of the financial establishments on each corner. From left to right

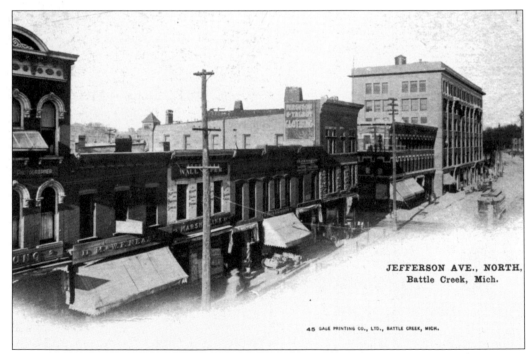

JEFFERSON AVE., NORTH,
Battle Creek, Mich.

45 SAGE PRINTING CO., LTD., BATTLE CREEK, MICH.

This early-1900s view of Jefferson Street shows the west side of the street. The three-story building on the left is the only structure still standing; it is the present home of the John Teravest Insurance Agency. The building in the middle of the picture, the Marsh and Link Paint and Wallpaper Store, was the City of Battle Creek's first municipal office location in 1859. The six-story building on the right was the 1905 Ward Building, the first fireproof building between Detroit and Chicago.

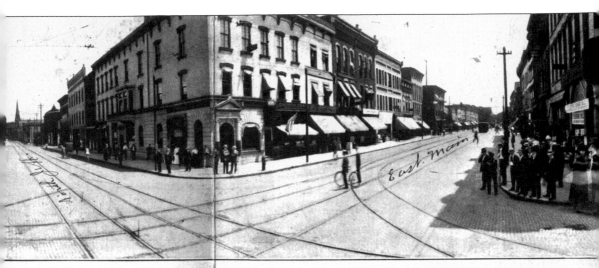

Copyright 1907, by U. S. Photo Co., Chicago, Ill., Publi

are the City Bank, the Central National Bank, and the Old National Bank. The steeple of St. Thomas Episcopal Church can be seen at the top of the hill on Jefferson Street.

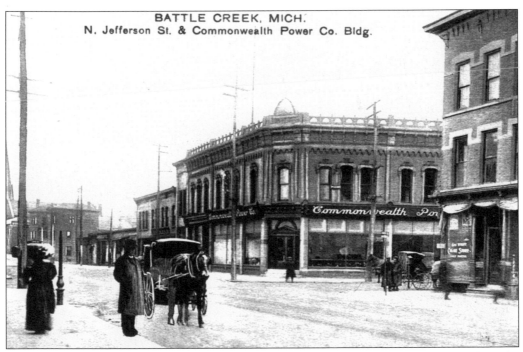

The Commonwealth Power Company was housed in the 1880 Nichols block located on the northeast corner of Jefferson Street (now Capital Avenue NE) and State Street. The building was the first permanent home for the U.S. post office in Battle Creek from 1880 until the post office building on the corner of Division and Main Streets (now East Michigan Avenue) was constructed and opened in 1908. In the 1940s, the building was extensively remodeled by the Consumers Power Company, and a third floor was added. The building was demolished in the late 1980s to make room for the W. K. Kellogg Foundation headquarters.

17

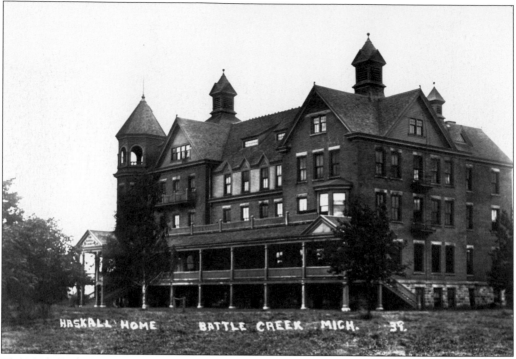

The Haskell Home orphanage was dedicated by the Seventh Day Adventist Church on January 25, 1894. Over 150 children could be housed in the structure, which was located near the site of the present Seventh Day Adventist Academy on Limit Street. Three children died in the fire that totally destroyed the building on February 5, 1909. A stone marker on the lawn of the academy commemorates the young lives lost.

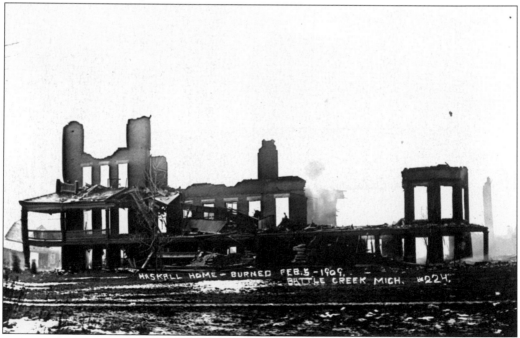

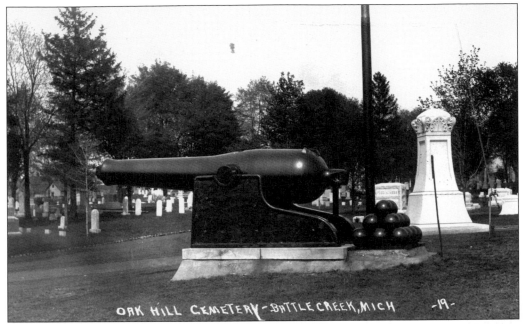

Oak Hill Cemetery was established in 1844. The American Civil War cannon was placed in the cemetery to commemorate the heroic service of Union soldiers and sailors. During World War II, the cannon was donated to help ease the metal shortage created by the war. The plaque that was attached to the cannon is on display in the cemetery office.

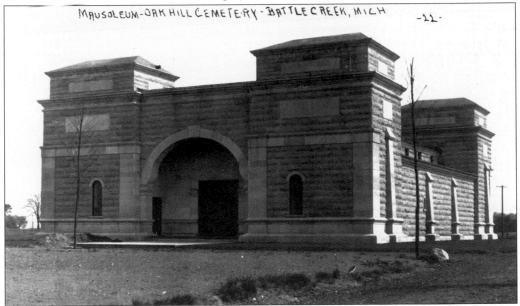

The Hamilton Mausoleum (also known as Oak Hill Abbey) was located in Oak Hill Cemetery. It was dedicated on February 4, 1912. During its years of service, the building housed 336 occupied crypts. In September 1953, the northwest corner tower collapsed. In 1978, the 176 remains still housed in the structure were removed and interred in an area 100 feet southwest of the mausoleum and identified with a stone monument listing their names. The structure was demolished in 1979.

On July 21, 1911, Irving Stone, the president of the Duplex Printing Press Company, donated land to the city to create a park. Irving Park, developed from a swampy, lowland area on the city's north side, was dedicated in 1924. Landscape architect T. Clifton Shepard created the park, which included streams, ponds, a 400-year-old white oak tree, and paths leading to rock gardens in the surrounding hills. Shepherd also worked to create Leila Arboretum.

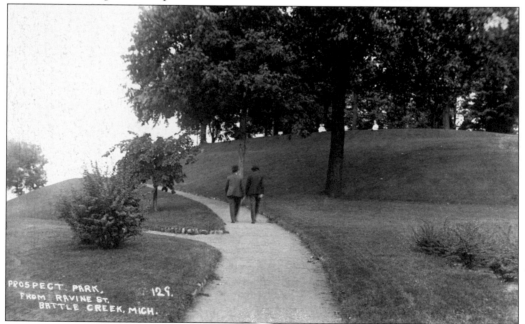

The city's second public park was Prospect Park. Originally known as Meachem Park (named for John Meachem, who donated the land), the two and a half acres were bordered by Fountain, Ravine (now Washington Avenue), and Rittenhouse Streets. The terraced area commanded a fine view of the city and contained paved walking paths, a fountain, and a waterfall between the steps from Ravine Street. (Courtesy of Carol Bennett.)

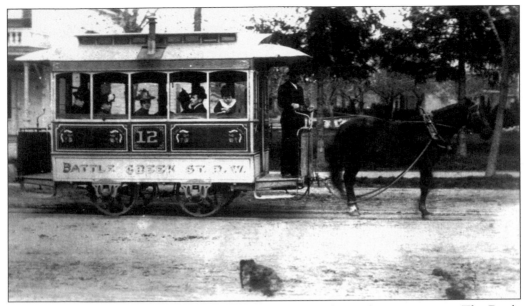

On June 30, 1883, tracks were laid for Battle Creek's first horse-drawn streetcars. The Battle Creek Railway Company was started by A. J. White. The early routes carried passengers from the Battle Creek Sanitarium on Washington Avenue to the Nichols and Shepard Factory on Marshall Street (now East Michigan Avenue). The company owned 24 horses and 6 streetcars and was very proud that each streetcar was equipped with wooden stoves to warm passengers in the winter.

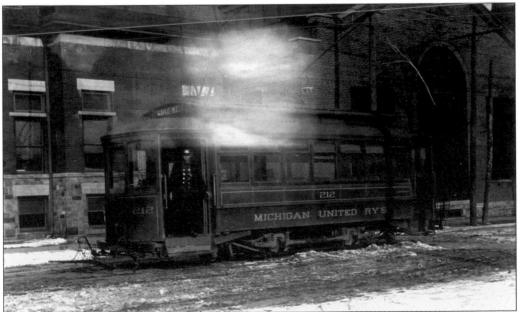

Michigan United Railway operated this streetcar on its Maple Street (now Capital Avenue NE) route. It is shown in front of the Advance Threshing Machine Factory (the present location of the Battle Creek City Garage) on Kendall Street. Originally started as the Case-Willard Thresher Manufacturing Company, it became the Advance Rumley Company on November 18, 1881.

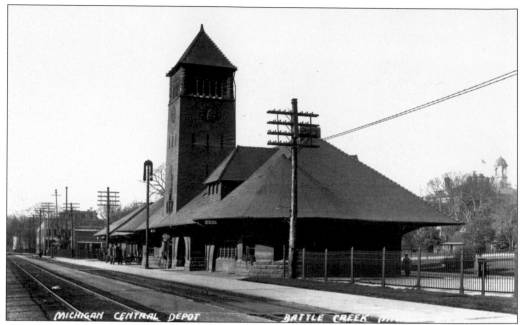

The Michigan Central Railroad Station (now the restaurant Clara's on the River) opened for service on June 27, 1888. The Romanesque-style building was designed by Rogers and McFarland of Detroit. The station was decorated in red oak and had separate ladies' and gentlemen's waiting rooms. The park between the station and Van Buren Street contained walking paths and the Ward Monument (see page 44). In the 1930s, as the need for more automobile parking increased, the park became a parking lot serving W. K. Kellogg Auditorium and Willard Library, as well as the station. The Ward Monument was moved to the southwest side of the station in the 1990s.

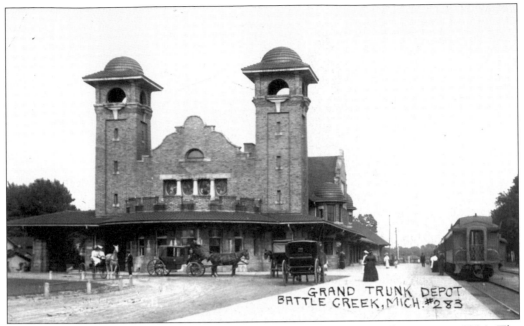

The Grand Trunk Railroad passenger station on Main Street opened in January 1906. The building was designed by Detroit architects Spier and Rohn at a cost of $75,000. The waiting room was 57 feet by 94 feet with a 30-foot-high ceiling. The walls were covered with nine-foot-high, white-glazed tile wainscoting with mosaic-tiled floors. For many years, a gardener created intricate floral displays welcoming visitors to the city. The building now houses the offices of the Community Action Agency of South Central Michigan.

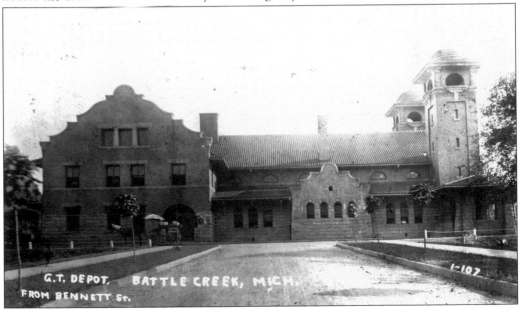

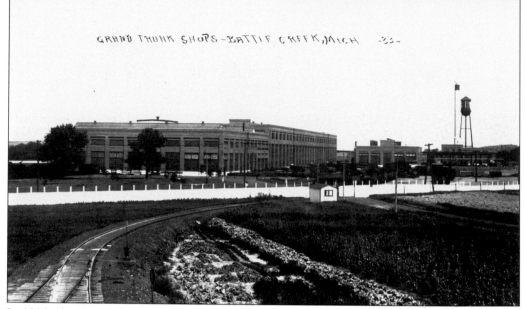

In 1908, the Grand Trunk Railroad moved its railway maintenance facility from Port Huron, Michigan, to Battle Creek. Designers of the $6 million Grand Trunk Railroad Shop were Arnold and Company Engineers. The 933-foot-long, 185-foot-wide building had an electric crane (the largest in the United States) capable of picking up a full-size steam engine. Presently the building, located behind the Porter Street Kellogg Factory, sits empty. The Grand Trunk Round House (approximately a quarter mile north) was built to complement the shop in 1924 and measured a circumference of 1,500 feet; it was demolished in the 1970s.

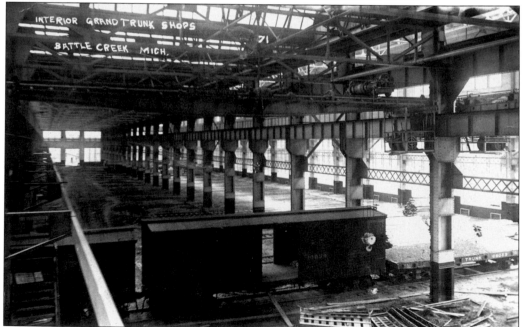

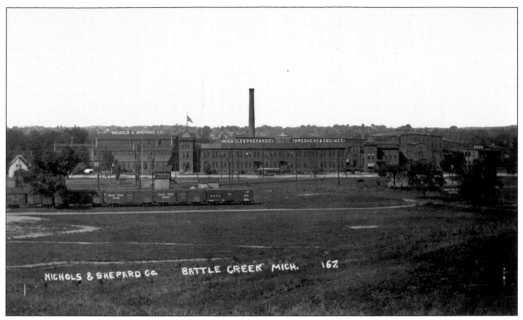

John Nichols made his first steam engine in 1854. John and his son Edwin Nichols joined with David Shepard in 1859 to create Nichols and Shepard Vibrating Threshing Machines and became incorporated in 1867. In 1869, they moved into this building on the corner of Union and Marshall Streets (now East Michigan Avenue). In the late 1800s, 10 percent of the nations threshing machines were being built in this factory. The company merged with the Oliver Corporation in 1929. This factory building closed in 1960. (Courtesy of Carol Bennett.)

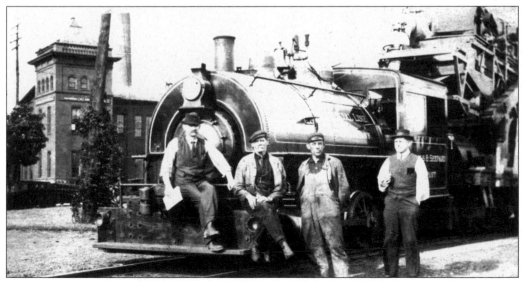

Small steam engines were used to move supplies around the Nichols and Shepard factory as shown with a few employees in this view outside the main building. This steam engine was featured in the 1931 Battle Creek Centennial Parade, pulling the Oliver Company's float (see page 126). (Courtesy of Carol Bennett.)

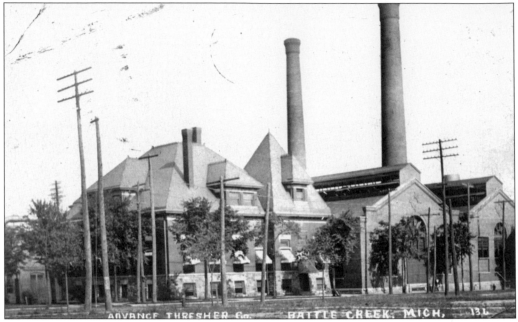

On November 18, 1883, the Case Willard Thresher Manufacturing Company opened this factory on Kendall Street. It was strategically located on 50 acres between the Michigan Central and Grand Trunk Railroad lines. Constantius G. Case designed the threshing machine after working at the Nichols and Shepard Company. It became the Advance Rumely Company in 1911. By 1919, with 1,450 workers, it was the largest employer in the city. Production at this location came to a close in 1930. The building was demolished in 2003.

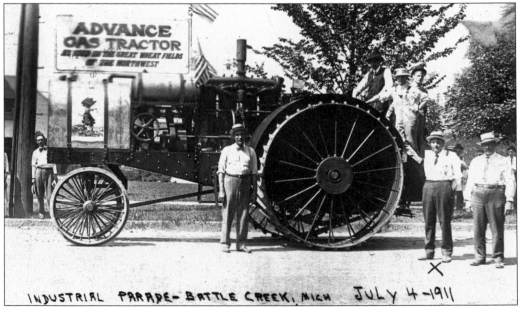

Decorated for the July 4, 1911, Industrial Parade, an Advance Rumely Threshing Machine awaits its turn on Van Buren Street in front of the Michigan Central Train Station (now Clara's on the River). The sign on the threshing machine says, "Advance Gas Tractor is used in the wheat fields of the northwest."

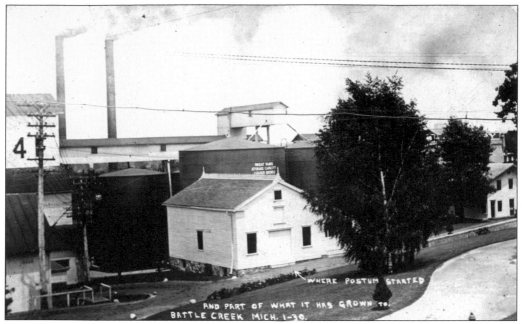

On January 1, 1895, in the small white barn on Cliff Street, C. W. Post began commercial production of Postum (a coffee substitute) with the assistance of his only employee, Clark "Shorty" Bristol. Over many years, the white barn has been moved to make way for newer factory buildings. Post had the new structures painted white, and the area was soon known as the White City.

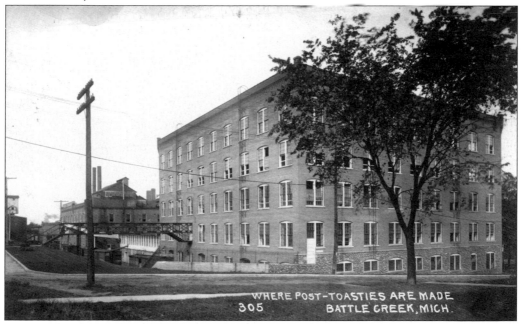

In 1908, this factory building was constructed near the corner of Marshall (now East Michigan Avenue) and Caine Streets, for the production of the breakfast cereal Post Toasties. This was the first of the large brick processing buildings that eventually replaced all the wooden White City structures.

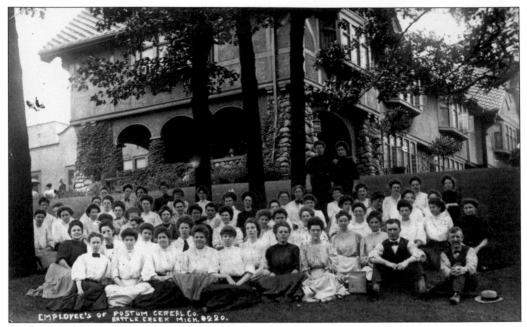

EMPLOYEE'S OF POSTUM CEREAL Co.
BATTLE CREEK MICH. #220.

This view is of some Postum Cereal Company employees in front of the English Tudor building that was originally the Grandin Advertising building. The building was designed by Chicago architect Joseph Llewellyn in 1904. C. W. Post's private office was on the second floor. A large number of artworks from Post's personal collection decorated the building. Much of the artwork was moved from the clubhouse to Post's daughter's home (Hillwood) in Washington, D.C., in the 1970s.

BRIDGE EASTANE PHOTO BY R.A. ADAM

Prior to the Union Street traffic bridge over the Battle Creek River that was constructed in the 1920s, employees of the cereal companies and the Nichols and Shepard factory crossed this footbridge to get from the residential areas near McKinley School over the river to work and back. (Courtesy of Carol Bennett.)

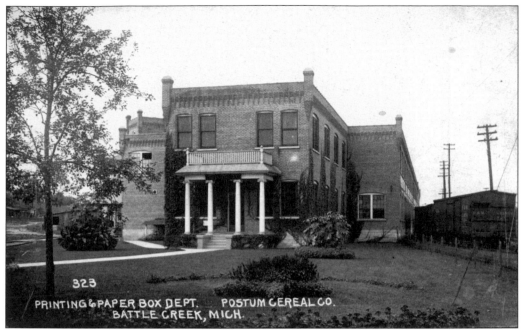

In 1889, to ensure a reliable source of paper to package his products, Post established the Battle Creek Paper Company adjacent to his cereal factory. In 1907, this brick, castlelike building with classical columns replaced the original structure. By the 1930s, the paper processor employed about 175 workers. (Courtesy of Carol Bennett.)

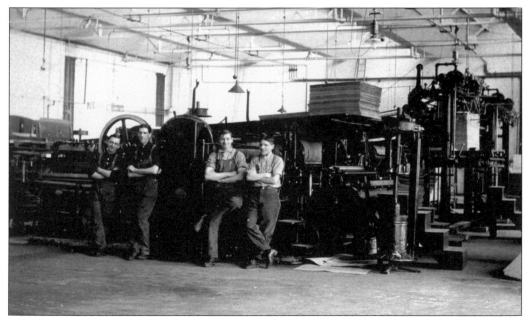

The back of this postcard says that one of the Battle Creek Paper Company workmen in this picture was Lee Werner, who started working for Postum Cereal Company on June 29, 1903. He retired after 45 years employment where he rose to printing shop foreman. He died in December 1975 at 93 years of age.

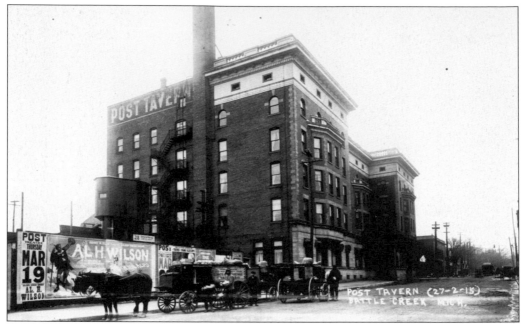

The Post Tavern hotel was built on the southwest corner of McCamly and Main Streets in 1901. C. W. Post had it constructed because he remembered his early days as a traveling salesman and the bad hotels he had to stay in. He did not want visitors to have the same bad experience. The hotel included 135 rooms and 40 private baths, an English-style pub, an elegant ladies' parlor carpeted in delft blue, and a "Lincoln Room" with a display of Civil War artifacts.

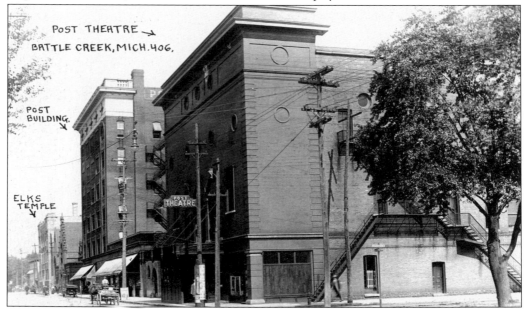

The Post Building (opened in 1901) and Post Theatre (opened on March 13, 1902) were constructed across the street from the Post Tavern on the city block bordered by Main (now West Michigan Avenue), McCamly, and Jackson Streets, creating a commercial and entertainment center. The theater was advertised as the "finest legitimate playhouse" between Detroit and Chicago. (Courtesy of Carol Bennett.)

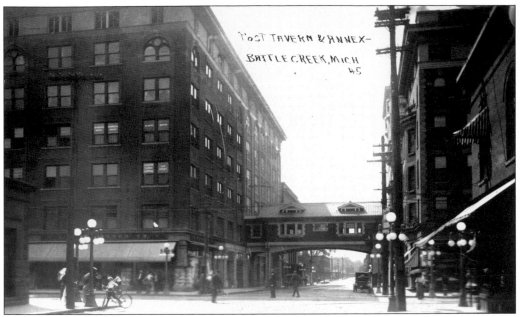

This approximately 1913 view is looking south on McCamly Street toward the enclosed bridge between the Post Building and the Post Tavern hotel. The bridge room was used for parties and could accommodate up to 270 people.

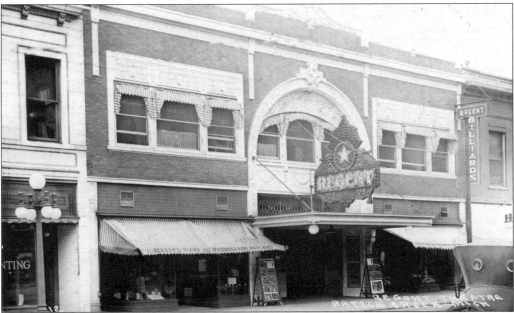

The Regent Theater was opened on November 18, 1918, at 78 Main Street. On November 27, 1918, it showed the first sound moving pictures in the city. Col. Walter Scott Butterfield, founder of Butterfield Theatres Incorporated, began acquiring movie theaters by renting the second floor of the old Hamblin Opera House on Main Street. In 1909, he built a new Bijou Theater just down the street. The colonel title was honorary, given to Butterfield by the troops at Fort Custer, in appreciation for his entertainment efforts during World War I. (Courtesy of Carol Bennett.)

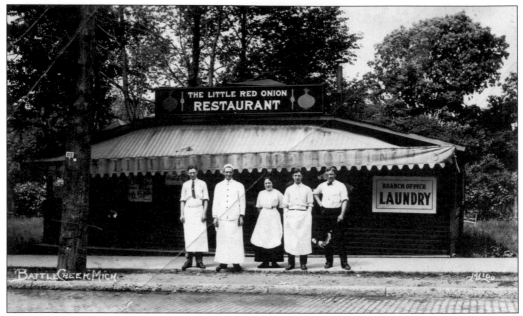

The Little Red Onion Restaurant is shown at its 49 North Washington Avenue location in about 1915. The restaurant's owner was Fred S. Gammanthaler. It is rumored that some of the patients from the health-conscious Battle Creek Sanitarium, which was located across the street, would go to the Red Onion to eat some of its nonvegetarian fare. (Courtesy of Carol Bennett.)

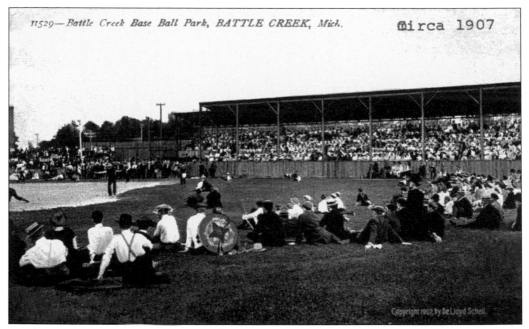

Athletic Park was located near the northwest corner of Columbia Avenue and Lake Street (now Capital Avenue SW). It was the site of many of the city's civic summer events being located near the cool breezes from Goguac Lake. This 1907 image is of a summer baseball game. The Battle Creek Lumber Company would pay $5 to anyone who could hit a ball over their sign in the outfield. The park was removed in 1921 when Lakeview School was constructed on the site.

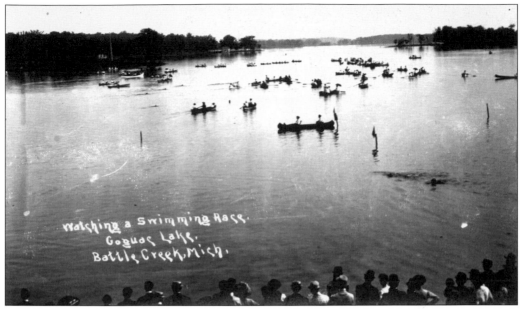

This early-1900s view is of a swimming race on the north side of Goguac Lake looking south toward Willard Public Beach. The first recreational boat on the lake was a sailboat. In 1865, a steamboat called *Peerless* gave the public excursions around the lake. In 1873, the Goguac Boat Club was organized and built a boathouse/clubhouse on Ward Island.

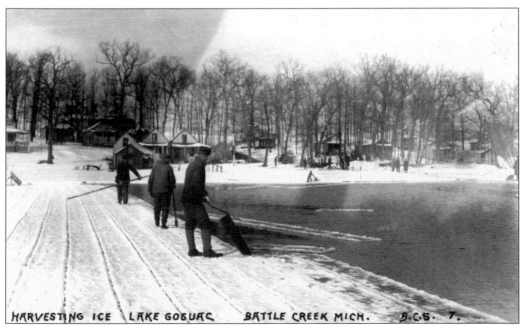

Before the perfection of electronic refrigeration, households had to use iceboxes to keep the food cool and fresh. In the winter, ice was cut from the surface of open water and kept in icehouses insulated by sawdust until it was needed in the warmer seasons. This early-1900s view of Goguac Lake shows the ice men cutting the ice blocks into manageable pieces.

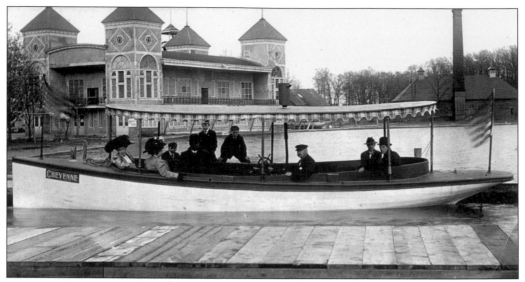

The *Cheyenne* is one of the boats that would take the public on excursions around Goguac Lake or to Picnic Island on the south side of the lake. In 1877, the island was sold to John Chamberlin, who built a hotel, and it became known as Chamberlin's Island. In 1887, Drs. H. M. and J. H. Beidler purchased 70 acres of land at the northeast end of the lake for $33 an acre. They created a real estate development known as Beidler Park.

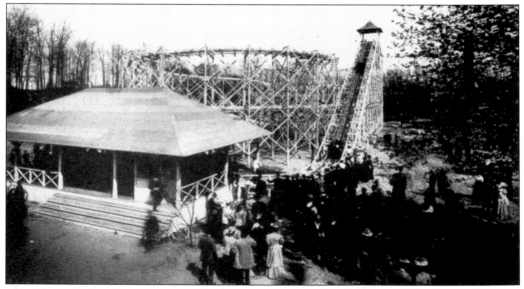

The Liberty Park roller coaster was located in the amusement park located on the north end of Goguac Lake. Originally the park contained only a hotel and boat livery called Surby's Resort when it was opened by R. W. Surby on June 3, 1875. It was sold to Mrs. Unna of Chicago. Early in the second decade of the 20th century, it was sold again and became an amusement park with merry-go-round, Ferris wheel, this roller coaster, and a large dance hall/bathhouse that had been purchased and transported from the St. Louis World's Fair (shown in the postcard at the top of the page).

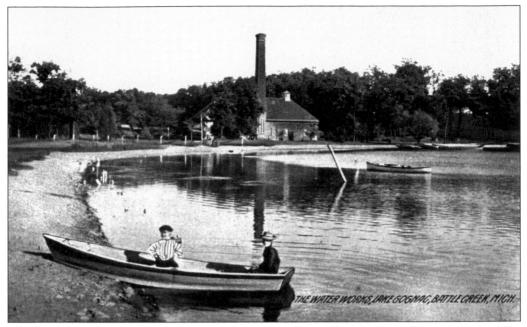

The Battle Creek City Waterworks were located in the northeast corner of Goguac Lake. The city used the lake for its drinking water when it opened this pumping facility on August 8, 1887. The building was used until the Verona Well Fields on the city's northeast side were made the main source of the city's water. Eventually wells were dug at the Goguac site to be used only in water emergencies. The standpipe was removed in 1953, and the pumping station was demolished in 1966.

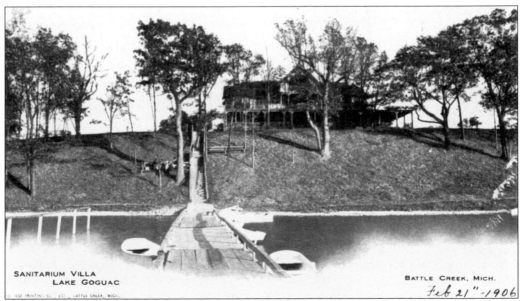

SANITARIUM VILLA
LAKE GOGUAC

BATTLE CREEK, MICH.
Feb 21"-1906

The Battle Creek Sanitarium built this villa on the northeastern shore of Goguac Lake in the late 1800s. Guests at the "San" could travel out to the south side of town to cool off and enjoy the healthy fresh air and sunshine on the shores of the lake.

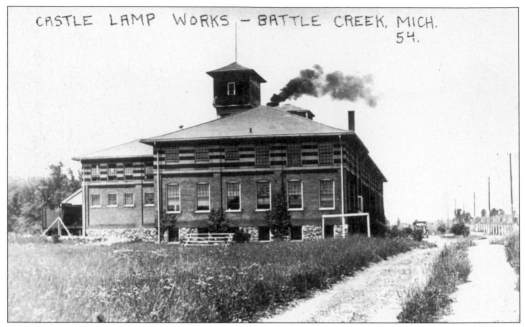

This is an early-1900s view of the Castle Lamp Works factory along the Michigan Central Railroad tracks near Lafayette Street. On June 17, 1912, the building was sold to the Corl Piano Company. The factory was purchased by the Battle Creek Sanitarium in 1921, to produce breakfast cereal as the Battle Creek Food Company. It went out of business in 1960 and was leased to the Nabisco Company until 1968. (Courtesy of Carol Bennett.)

This is the Duplex Printing Company business office located on the southwest corner of Houston and McCamly Streets in the early 1900s. The company started in 1884, when Joseph Cox (the founder of the *Morning Enquirer* newspaper and eventually the editor of the *Battle Creek Enquirer*) improved the flatbed newspaper printing press and started the Duplex Printing Press Company in 1890. The entire facility grew to an area that spread from McCamly Street to Washington Avenue.

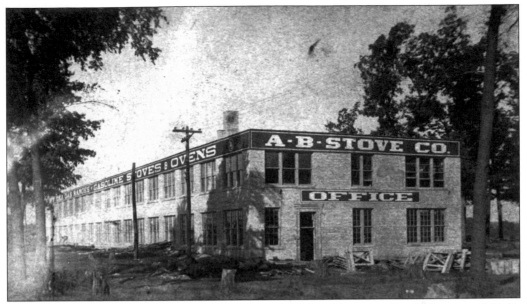

The AB Stove Company was organized in 1909 by John Alexander, Frank Berry, and P. C. Devil. The company name was derived from the original founder's initials. The C. W. Post Land Company donated the seven and a half acres of land near Angell Street and the Michigan Central Railroad tracks in exchange for $10,000 worth of stock. In 1936, it changed its name to AB Stove Incorporated and merged with the Michigan-Detroit Stove Company in 1945. In 1953, the facility was moved to Detroit.

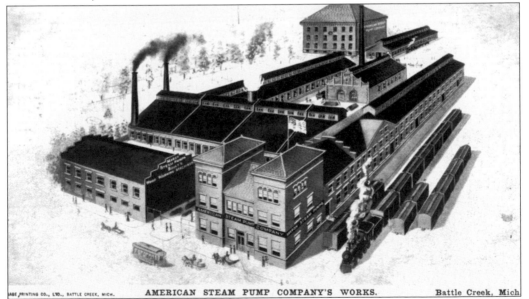

AMERICAN STEAM PUMP COMPANY'S WORKS. Battle Creek, Mich

In 1873, the Battle Creek Machinery Company was created to build woodworking machines. In 1888, due to a drop in the demand for that kind of equipment, the company began manufacturing pumps. In 1894, the name was changed to the Battle Creek Steam Pump Company and in 1899 became American Steam Pump. On February 12, 1960, the buildings were purchased by St. Philip Catholic Church and St. Thomas Episcopal Church and demolished; the area was made into a parking lot.

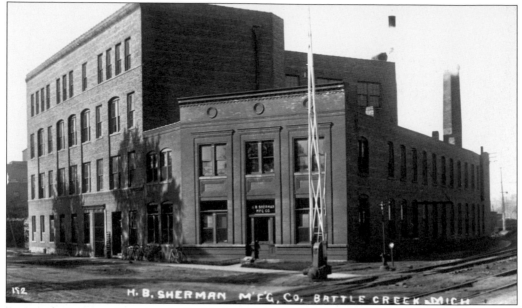

The H. B. Sherman Company built this four-story brick factory building with stone foundation in 1900 on the northwest corner of Kalamazoo (now West Jackson Street) and Barney (no longer exists) Streets. Howard Sherman, who as a local inventor and tinkerer, developed the Sherman Hose Clamp and founded the company to produce them in 1895. In 1927, he built a new residence on the southeast corner of Chestnut and Sherman (named after himself) Streets.

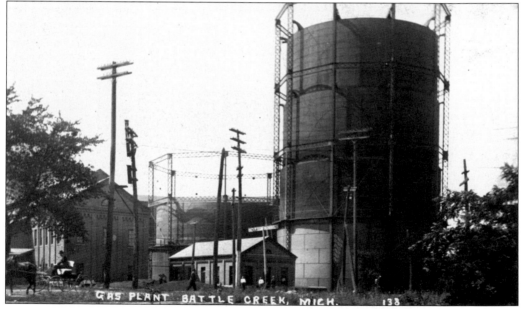

Starting the longest continuous business in the city, a group of bankers and businessmen organized the Battle Creek Gas Company in 1870. The city's first use of gaslights was at Clement Wackily's store on December 25, 1871. By 1872, 23 gas streetlights were installed in the downtown area. These gas tanks were located on the south side of Fountain Street near the Grand Trunk Railroad tracks. In 1974, the tanks were removed when gas storage was transferred to two underground caverns in Barry County.

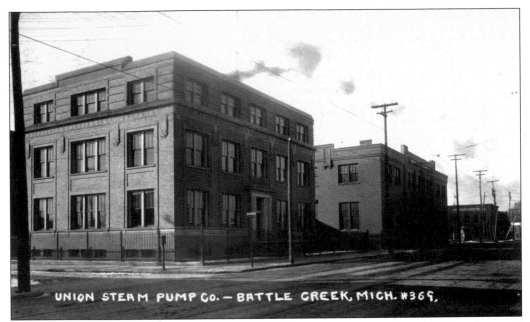

UNION STEAM PUMP CO. — BATTLE CREEK, MICH. #369,

In 1885, Union Steam Pump Company was organized. By 1931, it employed 500 workers and had an annual budget of almost $3 million. On February 3, 1959, its name was changed to Union Pump Company. Before moving out to the Fort Custer Industrial Park in the 1990s, the factory occupied the area bordered by the Grand Trunk Railroad tracks, Capital Avenue SW, Water Street, and Beacon Street.

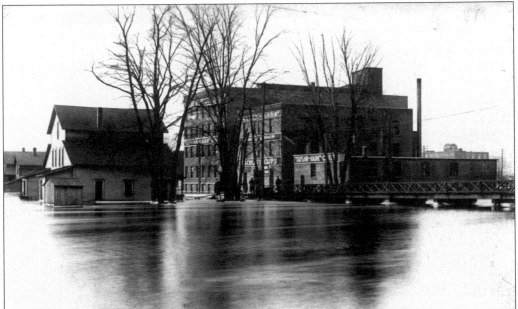

The 1904 downtown Battle Creek flood was cresting when this image was made of the Taylor Candy Company on Barney Street near the Kalamazoo River. Along with manufacturing confections to be sold nationally, a candy store outlet was located at 44 West Main (now West Michigan Avenue) in 1908. A fire damaged the company extensively on February 8, 1924. (Courtesy of Carol Bennett.)

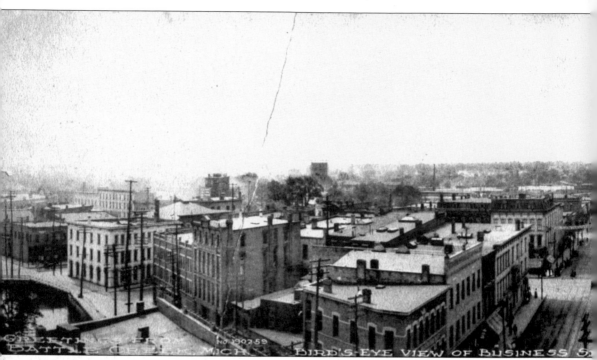

This panoramic image of downtown Battle Creek was made in the early 1900s looking south, toward the intersection of Jefferson and Main Streets. On the horizon, from left to right, is the fieldstone Binder building (known by its triangular shape), the large tank for the Battle Creek

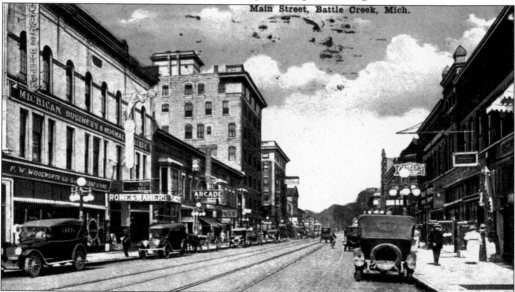

This view of Main Street (now West Michigan Avenue) looking west toward McCamly Street was made in the early 1900s. The Michigan and Normal Business College occupied the upper three floors of the same building containing the Bijou Theater. The Bijou Arcade, containing many small businesses, was created to augment the finances of the Butterfield Theaters Incorporated, which also owned the Bijou Theater. The Post Building and Post Tavern are the tall structures in the center of the picture.

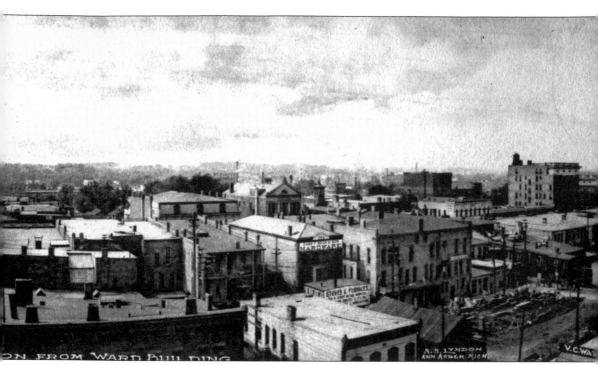

Gas Company, the roofs of the Hamblin Opera House and the Penniman building, the fire department tower behind Battle Creek's first city hall, the Post Theatre, the Post Building, and the Post Tavern.

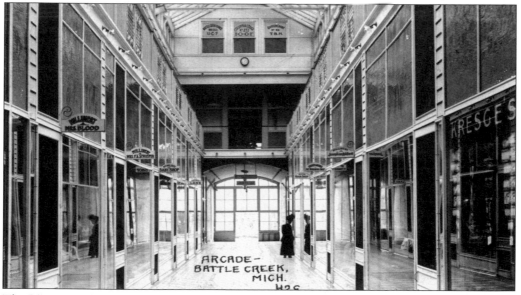

The Bijou Arcade, located at 45 Main Street (now West Michigan Avenue), was an area to pass between Main and Jackson Streets. It was constructed adjoining the Bijou Theater as a source of added revenue. Some of the businesses located in the arcade's Millinery Lane in the early 1900s are, from left to right, Mrs. Blood Millinery, Mrs. F. A. Schuster Millinery, Mrs. Milroy Baby Shop, the Arbor Tea Shop, Allan's Hair Shop, Roberts and Gardner Art Needlework Shop, Josephine Ashford Millinery, Kresge's, and assorted fraternal orders located on the second floor.

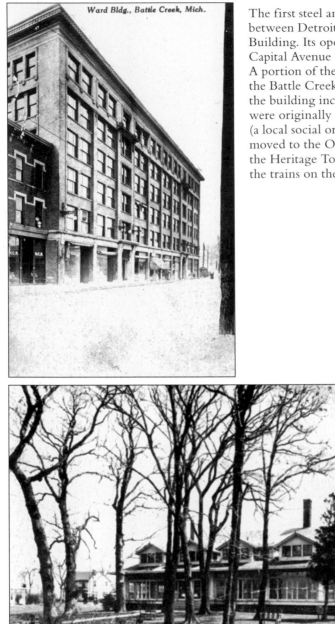

Ward Bldg., Battle Creek, Mich.

The first steel and concrete fireproof structure between Detroit and Chicago was the Ward Building. Its opening on Jefferson Street (now Capital Avenue NE) was on October 10, 1905. A portion of the building was constructed over the Battle Creek River. The top three floors of the building included a large auditorium and were originally occupied by the Athelstan Club (a local social organization). In 1931, the club moved to the Old Merchant National Bank (now the Heritage Tower) because of the smoke from the trains on the Michigan Central Railroad.

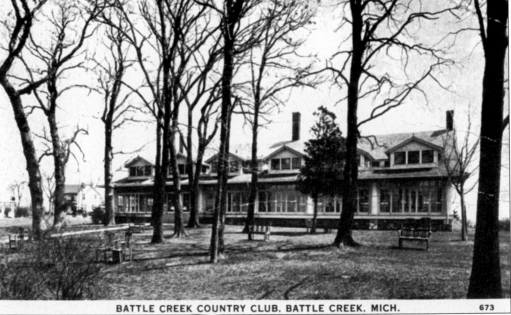

BATTLE CREEK COUNTRY CLUB, BATTLE CREEK, MICH. 673

In 1919, the Battle Creek Country Club moved from its location on West Main Street (now West Michigan Avenue) to this site on Goguac Lake. The lakeshore property had belonged to Carroll L. Post (the brother of C. W. Post) and was used as a clubhouse until a new building was constructed in the late 1950s. The spacious golf course was the former farm of Goddard-Smith-Jennings-Rice-Reasoner.

The eight-story City National Bank Building was designed by Jackson–Casse Engineers from Chicago. Local contractor S. B. Cole began work on the structure in 1915. A local newspaper described it as "built in the American Style [which] gives the building an air of stability and strength." The bank remained solvent through the Great Depression, and in 1941, it was incorporated into the Michigan National Bank. The building was demolished in the 1980s.

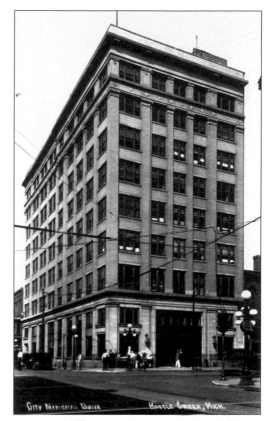

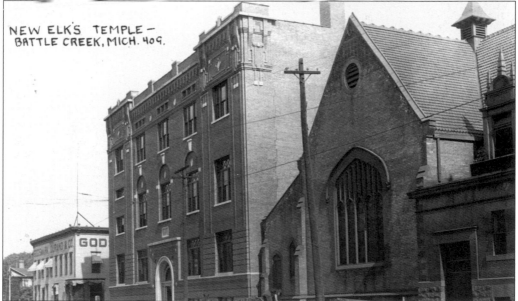

The Elks Temple Lodge No. 131 opened on the southeast corner of State and McCamly Streets in 1911. The redbrick and Bedford limestone, Italian Renaissance–style building was designed by Milwaukee architect Henry C. Hengels at cost of $65,000. The old First Presbyterian Church is on the right. The building was demolished in 1987. (Courtesy of Carol Bennett.)

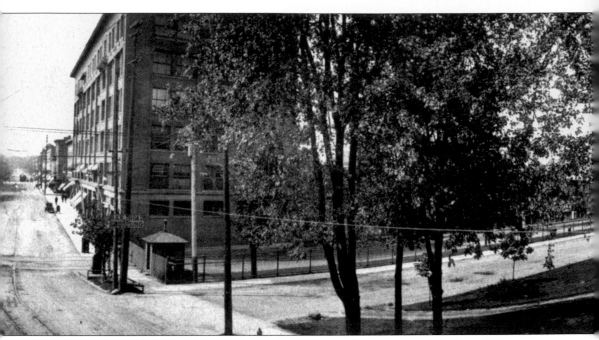

This double card shows the Ward Building, the Michigan Central Railroad Station, and the Charles Willard Library located along Jefferson Street (now Capital Avenue NE). The six-story Ward Building was opened in 1905 on the site of the Joseph M. Ward Flouring Mills. The Michigan Central Railroad Station was opened in 1888. Willard Library opened on April 28,

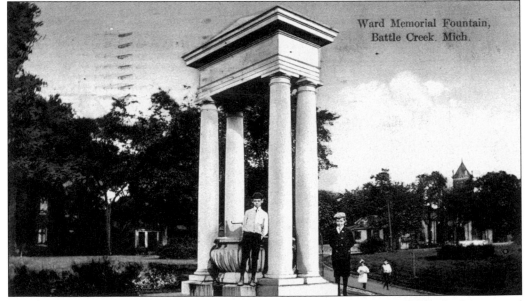

The Ward Monument was built in 1908 by Charles Ward in memory of Charles Mason and Joseph Marshall Ward. In 1848, they joined together and founded the Michigan Woolen Mill. In 1860, Ward bought full ownership and converted the mill into a flouring mill. The four-columned monument stood in the park behind the Michigan Central Station (see page 22) and was eventually moved to the southwest side of the station. The spire from the 1879 St. Philip Catholic Church can be seen in the background.

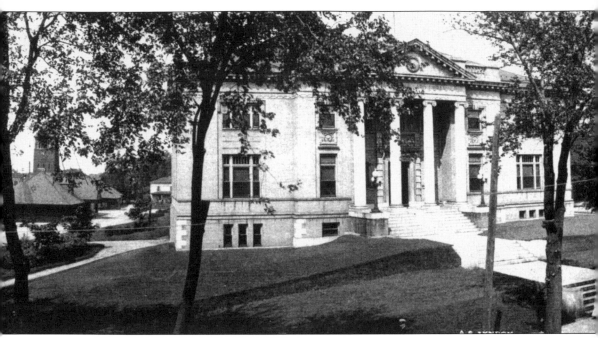

1905. The neoclassical structure facing Jefferson Street was designed by Chicago architect Joseph Llewellyn. The building features four Granite columns, the lobby was clad in white marble, and the two-story reading room was open to a skylight.

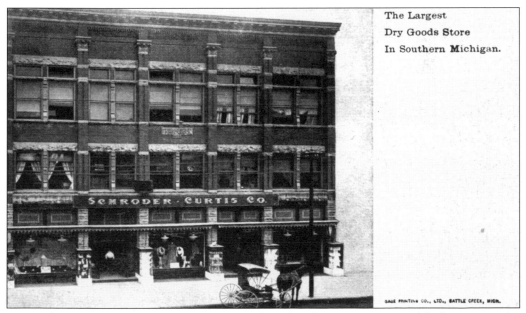

The Largest
Dry Goods Store
In Southern Michigan.

In October 1900, the Shroder Curtis Dry Goods and Millinery Store opened for business in the Trump Block, located at 33–37 West Main Street (now West Michigan Avenue). The building had formerly been occupied by L. W. Robinson's. On February 1, 1907, it became the Schroder Curtis Company and remained at this site until 1928.

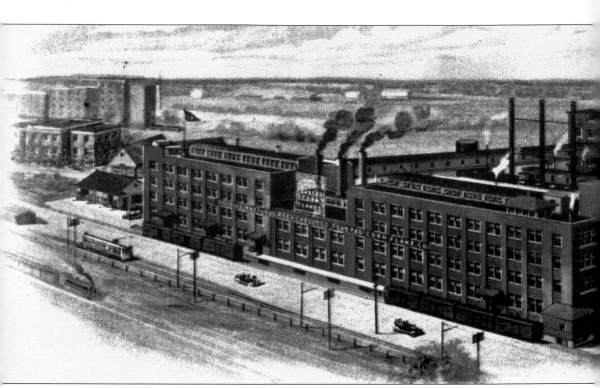

After a fire burned the Kellogg Company's Bartlett Street factory on July 4, 1907, W. K. Kellogg purchased the Budge farm on Porter Street, located between the Michigan Central and Grand

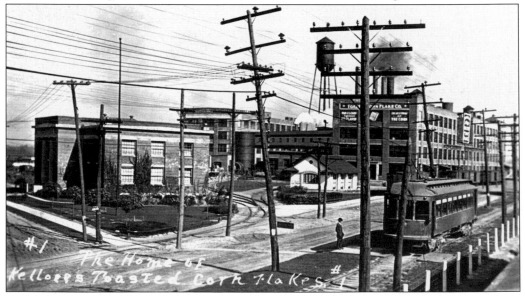

In the mid-1930s, the Kellogg Factory occupied 30 acres and employed 2,000 people, working around the clock to produce over 16,000 cases of cereal each day. The factory included a nursery for workers' children, and the company provided free dental and medical care for employees. A rose garden with fountain, tennis courts, playground, baseball diamond, horseshoe courts, and other recreational areas were constructed as part of W. K. Kellogg's efforts to help the local economy during the Great Depression. (Courtesy of Carol Bennett.)

46

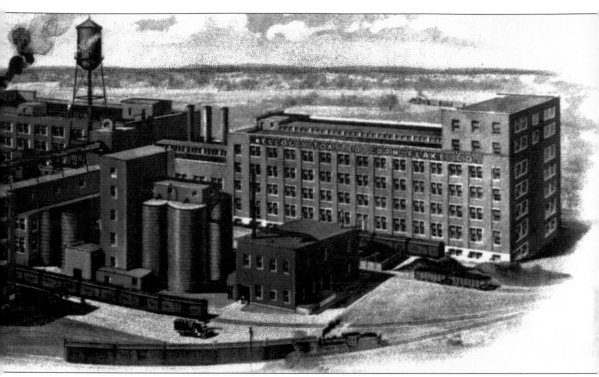

Trunk Railroads, to construct the new factory. The building opened in January 1908, designed by Chicago architect M. J. Morehouse.

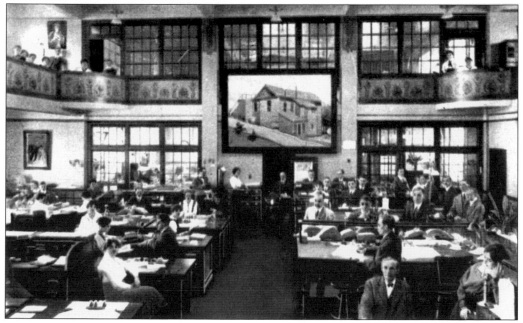

This is the Kellogg Company main office. A "Rest Balcony" was located above the main floor where office workers could relax during breaks and step away from their desks. W. K. Kellogg's office was at one end of the second-floor balcony. The large picture hanging at the end of the room is the original 1906 Kellogg factory on Brook Street.

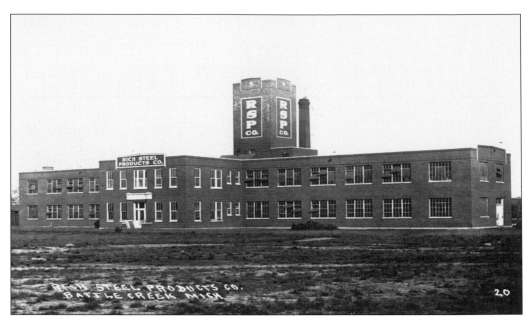

This 1920s view is of the Rich Steel Products Company on Avenue C. It produced engine valves and tappets for automobiles and airplanes. The company was established in 1916 by George R. Rich. In 1928, it became part of the Wilcox-Rich Corporation and in 1929 was enlarged by the addition of the Rich Tool Company from Detroit. In 1930, it became part of the Eaton Corporation. (Courtesy of Carol Bennett.)

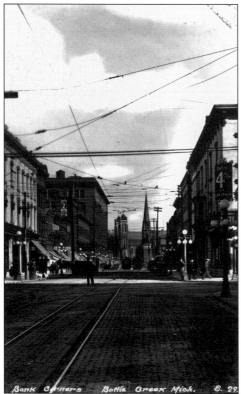

This image, from the second decade of the 20th century, shows "Bank Corners" looking north on Jefferson Street (now Capital Avenue NE) with two streetcars passing side by side. Some of the businesses are, from left to right, Baker Drug Store, Central Electric Company, the Ward Building, St. Philip Catholic Church's 1914 building, St. Thomas Episcopal Church, and the Old National Bank.

C. W. Post came to Battle Creek to find a cure for his general malaise and found his way to a financial fortune. He never found relief from his illness, and after an emergency operation at the Mayo Clinic, he returned to his home in Santa Barbara, California, where he committed suicide on May 9, 1914. His body was returned to Battle Creek in 1915 for an elaborate funeral and interment in a new mausoleum at Oakhill Cemetery. This image is of C. W. Post's funeral procession passing the First Methodist Episcopal Church on Main Street.

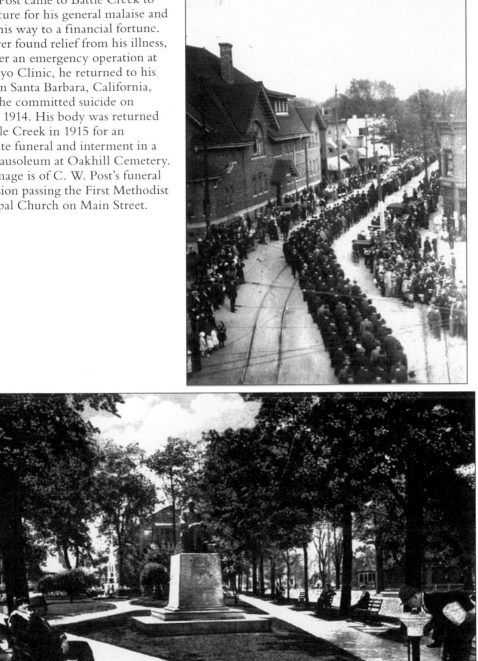

This small triangle of land bordered by South Avenue and Division and Jackson Streets was known as Monument Park. After the statue of cereal magnate C. W. Post, designed and executed by sculptor J. Gelert, was erected by the citizens of Battle Creek in 1916, the park was called Post Park. A stone history tower or cairn at the far end of the park was built in the 1930s by James H. Brown.

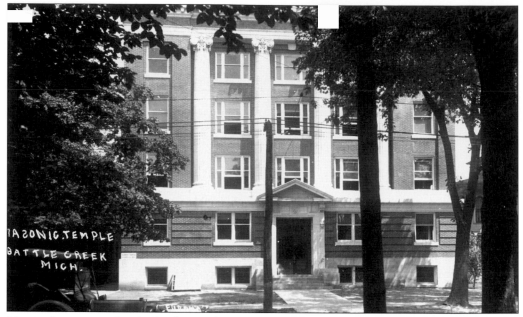

Masons began meeting in Battle Creek in 1836. In 1913, construction began on the Masonic temple, designed by the Grand Rapids architectural firm of Osgood and Osgood. The five-story temple, built of Wadsworth paving brick and trimmed in white terra-cotta, was dedicated in 1914. The $85,000 building contains lodge rooms, a dining room, ceremonial space, and a large auditorium that can be used for a ballroom. It is the site of the first log cabin built in Battle Creek recognized by a marker in front of the present building.

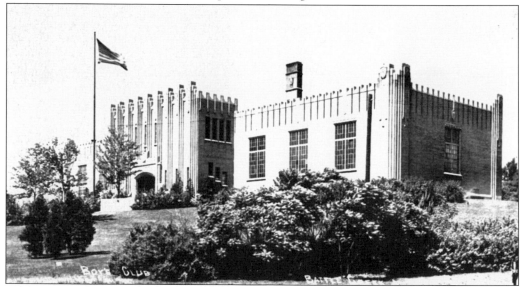

The Associated Boys Club was presented with this building from an anonymous donor (W. K. Kellogg) on June 14, 1928. Built on Mykin's Hill, the structure was designed by the Grand Rapids architectural firm of Benjamin and Benjamin and constructed by local contractor S. B. Cole (whose home is on page 122). The building contained a swimming pool with bleachers, gymnasiums, a dining room, a band room, and support facilities. From 1937 until 1988, it was known as the Youth Building.

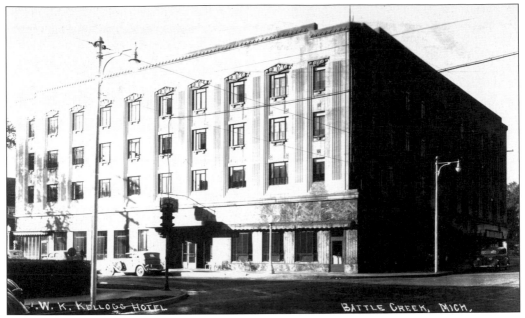

The Kellogg Hotel opened on the northwest corner of Washington Avenue and Van Buren Street in 1930 as competition with the Post Tavern. The art deco, Indiana limestone building was designed by Chicago architect M. J. Morehouse, who also designed Kellogg's Porter Street factory. The parlor contained a Belgian black marble fireplace. On February 1, 1938, the hotel was purchased by Thomas P. Hart, who changed the name to the Hart Hotel. (Courtesy of Carol Bennett.)

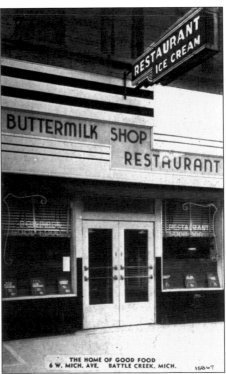

The Buttermilk Shop was originally opened in the 1930s by Fred Dowding. Buttermilk was recommended by the Battle Creek Sanitarium as "good for your interior." It was located at 6 West Michigan Avenue but had a side entrance from Capital Avenue NE. It was sold to Ralph Strangland and Charlie Spars and lasted through World War II's military patronage, then closed in 1946.

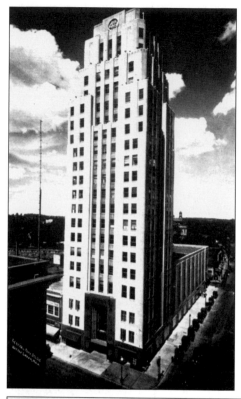

The 18-story Central National Bank was opened in 1931 on the northwest corner of McCamly Street and West Michigan Avenue. It was designed by Chicago architects Holabird and Root. The exterior is clad in Indiana limestone, and there is a bronze panel over the main entrance depicting "Progress of Community." There is an underground parking lot and a penthouse called the Skylark's Nest, originally occupied by the bank president, Ezra Clark, the founder of Clark Equipment Company. In 1972, it was renamed the Wolverine Tower; in 1984, it became the Transamerica Building and is presently known as the Battle Creek Tower.

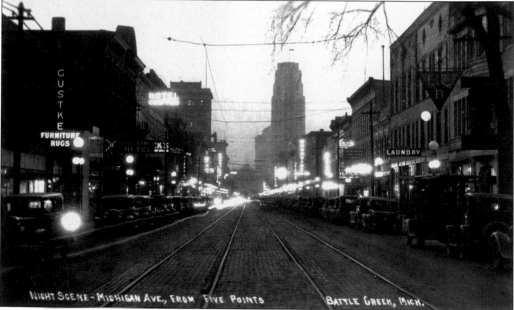

This 1930s view of East Michigan Avenue looking west from in front of the U.S. post office shows a downtown full of small and large businesses. Among them are, from left to right, Gustke Furniture and Rugs, the Lavern Hotel, the Hotel Clifton, the City National Bank Building, the Central National Bank Tower with construction scaffolding, the Elite Movie Theater, and Helen Douglas' Home Cooked Lunch. (Courtesy of Carol Bennett.)

The Old Merchant National Bank built a 20-story office building in 1931 on the West Michigan Avenue site of the old city hall. The formal public opening was held on August 15, 1931. The gray Indiana limestone structure was designed by the Chicago architectural firm of Weary and Alford at a cost of $1.7 million. Murals painted with gold leaf were designed to show symbols in a banking motif that included squirrels and honeybees decorating the 46-foot-high banking room.

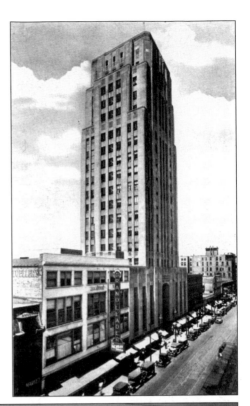

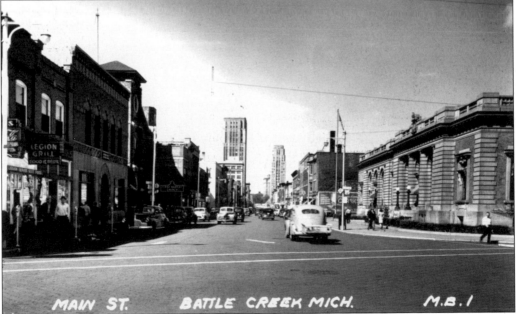

This view of East Michigan Avenue looks west from the intersection with Division Street, in the early 1940s. Many businesses were still thriving with, from left to right, the Legion Grill in the Bromberg Block, the Bell Telephone Company, the First Baptist Church, the City National Bank Building with a tall radio tower, the Old Merchant Bank Building, the Central National Bank, and the U.S. post office.

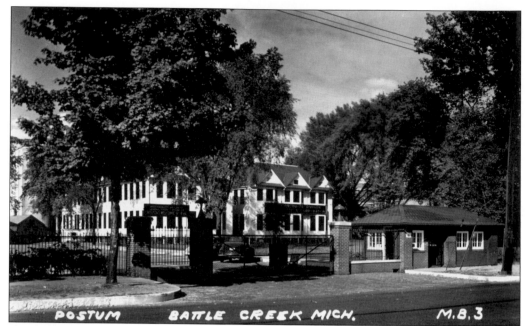

The Postum Cereal Company began giving tours of the Cliff Street factory in 1905. In 1957, the plant manager decided to end the public tours and announced that the Kellogg Company would also stop the tours. This view of the Post Cereal Cliff Street gatehouse was taken in the mid-1950s.

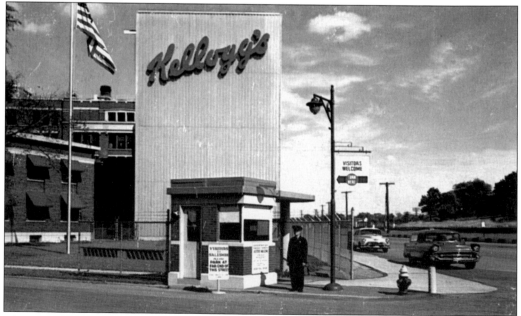

This is a 1960s view of the Kellogg Company visitor's entrance on Porter Street. The factory tours began here in 1912 and were hosted by a "genial cornologist" named Professor Olmstead. Because of fear of corporate espionage and health concerns, the public tours came to an end on April 12, 1986.

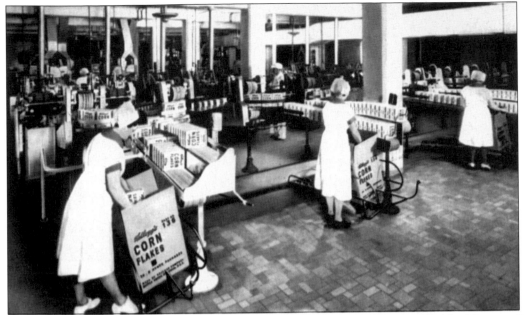

This 1950s view of the Kellogg Company interior shows workers placing individual boxes of Kellogg's Corn Flakes into larger cases for shipping. W. K. Kellogg was a pioneer in hiring women to work in his factory and developing a six-hour work shift during the Great Depression to put as many people to work as possible.

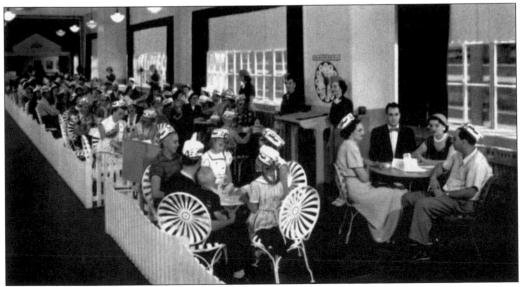

These 1960s visitors have come to the end of the mile-long, free public tour of the Kellogg factory. Before the tours were ended in 1986, over six million guests toured the plant. The tour ended with a bowl of ice cream with Cocoa Crispies or Fruit Loops and a free snack pack that included six small individual boxes of Kellogg's cereal.

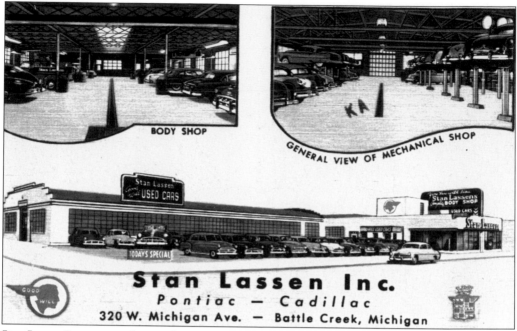

BODY SHOP

GENERAL VIEW OF MECHANICAL SHOP

Stan Lassen Inc.
Pontiac — Cadillac
320 W. Michigan Ave. — Battle Creek, Michigan

Stan Lassen Incorporated opened in October 1931 as a Nash Automobile dealer with 18 employees at 482 West Michigan Avenue. On May 15, 1937, the business moved to 320 West Michigan Avenue and specialized in selling Pontiac and Cadillac automobiles.

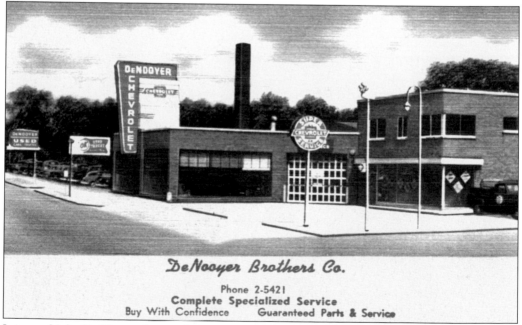

DeNooyer Brothers Co.

Phone 2-5421
Complete Specialized Service
Buy With Confidence Guaranteed Parts & Service

Jerry and Jake DeNooyer began their automobile business with the Barnhart Motor Company at 11 South Washington Avenue. On May 29, 1928, they moved their DeNooyer Brothers automobile company to 350 West Michigan Avenue. A fire destroyed the building on February 9, 1933, so they temporarily moved to 100 West Michigan Avenue until they could rebuild the fire-damaged building.

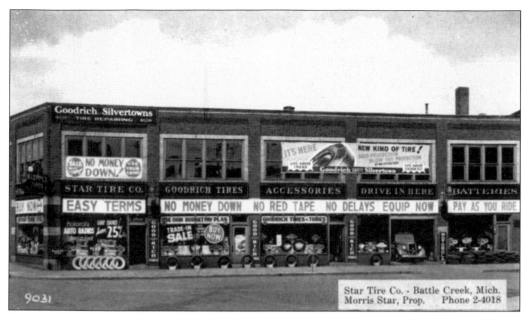

Morris Star opened this Star Tire Store on the southwest corner of Jackson and River Streets on August 8, 1938. On October 28, 1948, he opened a Home and Automobile Supply store at 208 West Michigan Avenue. Brothers Julius and Mitchell Star also owned and operated automobile, appliance, and furniture stores in the city. (Courtesy of Carol Bennett.)

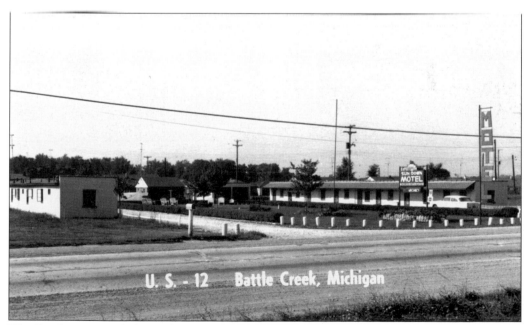

The Sundown Motel, located at 625 West Columbia Avenue (U.S. Highway 12), opened to serve the automobile traveling public in the late 1940s by Kenneth Bailey. In 1955, the motel could boast individual showers and heat in 16 units. The business later moved to 1149 West Columbia Avenue.

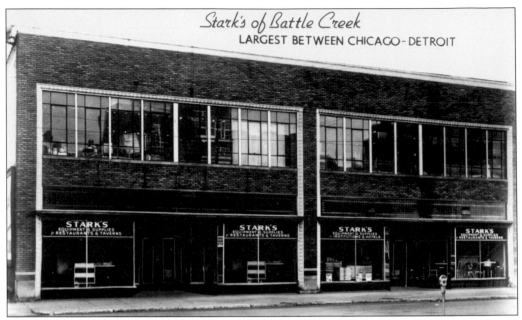

On April 13, 1946, Clarence Stark opened Stark's Wholesale Restaurant Supplies at 10–16 West State Street. The business had started years earlier, by just selling large dishes and china at 95 West Michigan Avenue. In 1979, the business moved to a Twentieth Street location.

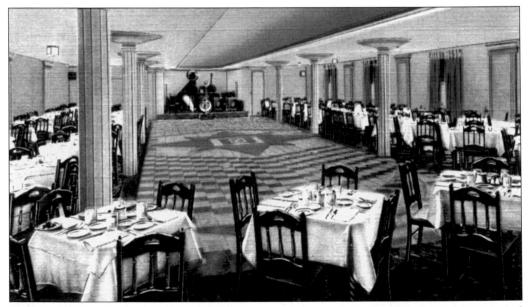

This is a 1940s image of the Hi-lo Club that was located in the LaSalle Hotel at 45 Capital Avenue SE when it opened as a bar and restaurant in 1933. It featured national traveling bands and local groups. The hotel was purchased by Phillip Gilbert in 1952, which changed the name to the Gilbert Hotel. Del Shannon, made famous with his recording of "Runaway," performed there for the first time in 1961. A State of Michigan historical marker commemorating Shannon occupies the site of the hotel that was demolished in 1984.

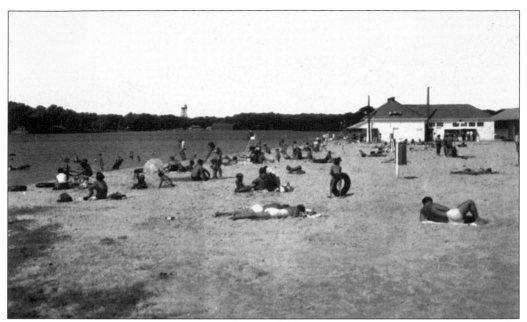

Willard Beach on Goguac Lake was donated to the city in 1897 by Charles Willard. The 16 acres of land on the east shore of the lake was to be maintained as a public park. After World War II ended, the City of Battle Creek made improvements to the park, including a large picnic pavilion, a bathhouse, and a concession stand, which are shown in this 1960s photograph of the beach looking northward.

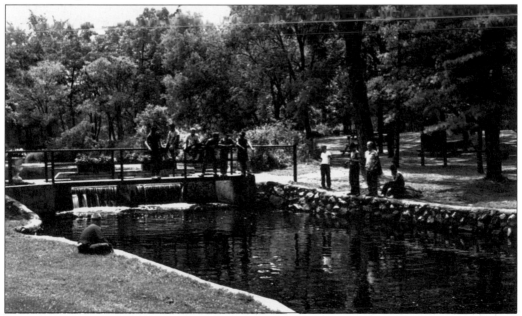

This 1960s view is of the dam and waterfall in Binder Park. On January 2, 1958, Charles Binder Park opened south of the city on the 656 acres of land donated by Binder's wife, Cecilia, in his memory. Binder was a local meat merchant who had originally purchased the land because he enjoyed riding horses in the countryside. The city-owned park is now home to a golf course, picnic area, and the Binder Park Zoo that opened on Memorial Day 1977.

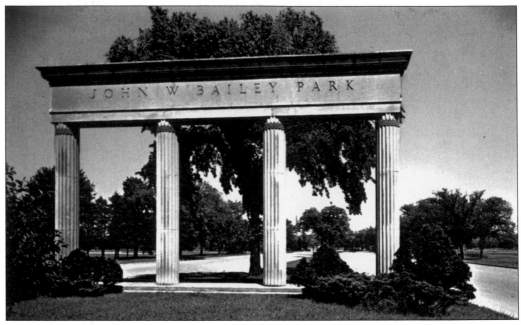

In 1928, plans were announced to build a Verona Park recreation area between Maple Street (now Capital Avenue NE) and the "Battle Creek Stream." The landscape was designed by T. Clifton Shepherd, who had also designed Leila Arboretum, Piper Park, and eventually the grounds of Percy Jones Army Hospital. The park was named after the popular Battle Creek mayor John W. Bailey at a dedication that took place in the 1930s.

Organized baseball goes back to neighborhood teams playing in local fields in the 1870s. By 1924, organized league play had begun. Bailey Park dedicated its 1,700-seat No. 2 brick stadium on May 18, 1936, and began hosting an annual baseball tournament. As part of a $4.7 million Bailey Park renovation project, an enlarged 6,008-seat baseball stadium was opened on July 4, 1990. The stadium was named after local baseball organizer Cooper Othneil Brown.

The 10-story addition to the Post Tavern (see page 30 and 31), on the northwest corner of McCamly and Jackson Streets, was built in 1912–1913. The original six-story building was demolished in 1960 and made into a parking lot. Hoping to appeal to the automobile travelers, it was renamed the Post Tavern Motor Inn. It was demolished in 1970.

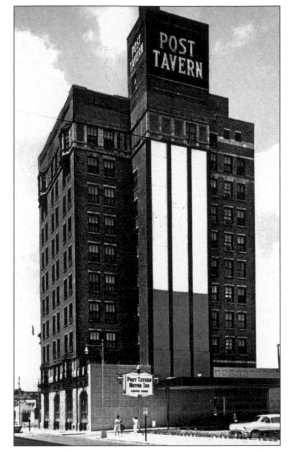

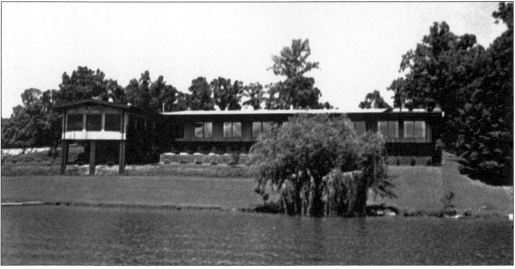

The Lakewood Inn was located on Hulbert Lane, off West Columbia Avenue, overlooking the north side of Goguac Lake. Owners Richard Eddinger and Mark Steinbrunner opened the restaurant/bar on August 3, 1963. In the 1980s, it was sold and renamed Princes on the Lake and Gabriel's. Presently it is known as the Waterfront Restaurant.

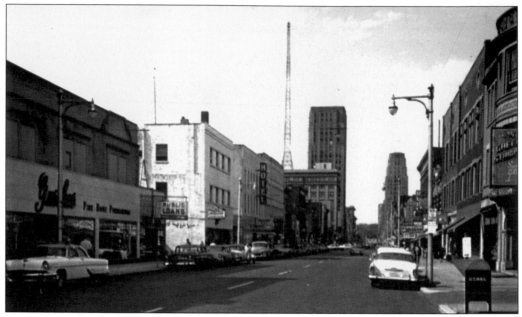

This 1960s view of East Michigan Avenue looking west from the front of the U.S. post office shows, from left to right, Gustke's Fine Home Furnishing, a public loans business, the Williams House Hotel, the Michigan National Bank Building, the Security National Bank building, and the Wolverine Tower (see pages 13, 52, and 53 to see changes).

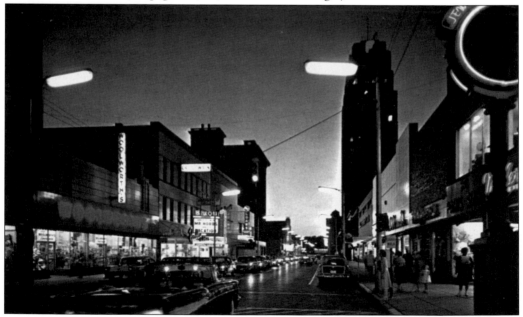

In the 1960s and 1970s, a popular activity for teenagers was repeatedly driving through downtown on weekend evenings. It was called "cruising the gut." It ended in the 1970s when the Michigan Mall was built and closed off "thru-traffic." After the pedestrian mall was removed in the 1990s, a group of local police officers obtained permission to close off Michigan Avenue through the downtown area one Saturday each summer, where classic car collectors "cruise the gut" again.

Cherry Hill Manor senior center was opened on Clay Street in 1970. The 150 apartments were built by the City of Battle Creek to assist senior citizens in obtaining affordable places to live.

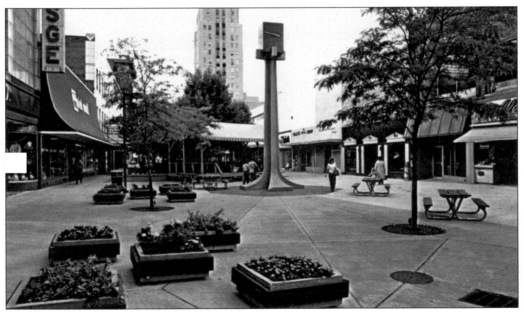

After many years of debate, the Michigan Mall was dedicated on June 27, 1975, at a cost of $2 million. The pedestrian mall through the downtown area had been suggested since the 1950s but only became a reality when business owner Kermit Krum became instrumental in rallying the public and city government to back the project. The mall was removed in the late 1990s, and Michigan Avenue was once again open to automobile traffic. (Courtesy of the Alex Fisher Collection.)

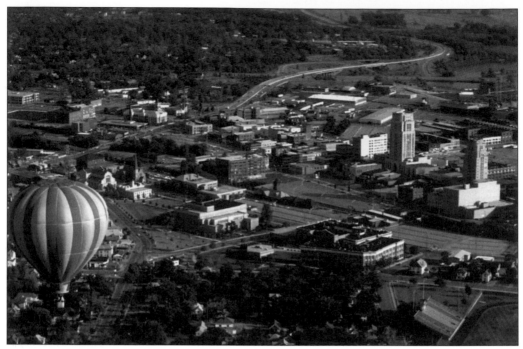

On June 20, 1981, the City of Battle Creek hosted the Fifth World Hot Air Balloon Championship at Kellogg Regional Airport. Some 200,000 people watched the 75 balloons from 23 countries compete in the event sponsored by the Battle Creek Area Chamber of Commerce and the Kellogg Company. Since that time the city has hosted an annual hot-air balloon event each summer, attracting thousands of visitors to the area. This view is looking south over downtown.

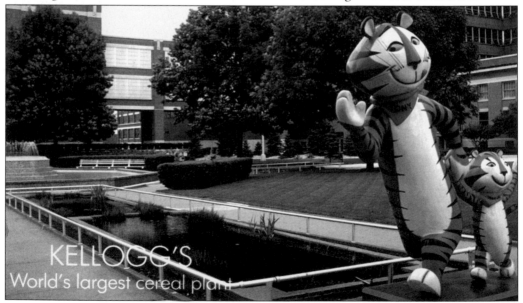

The Kellogg Company factory on Porter Street hosted visitor tours starting in 1912. Because of corporate espionage and health concerns, the factory tours ended on April 11, 1986. These statues of Tony the Tiger and Tony Junior greeted guests by the large entrance fountain. At the time of its closing, it was the second most popular free tour in Michigan.

As part of a downtown redevelopment project, the McCamly Square complex included, from the bottom to the top, the 15-floor Stouffer Hotel (opened in 1981), the Kellogg Center arena, the McCamly Place shopping mall (opened in 1986), a large parking structure, and the Kellogg Company Corporate Headquarters (opened in 1986). On November 23, 1981, the 15-floor Stouffer Hotel opened with 248 rooms, including 15 luxury suites, a 600-seat ballroom, two restaurants, and an indoor pool. It was renamed the McCamly Plaza Hotel in the 1990s.

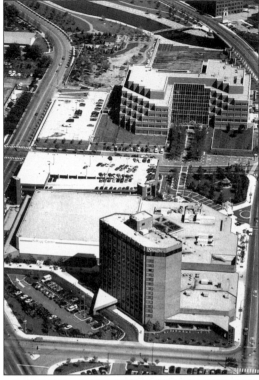

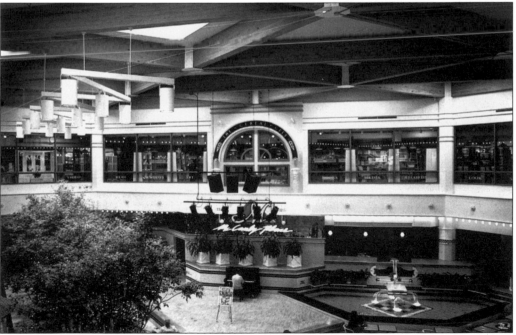

On April 19, 1986, McCamly Place, a bi-level festival marketplace opened to complete the McCamly Square complex. The facility was designed by Collaborative Incorporated from Toledo, Ohio. The prairie-style central atrium held a public stage/fountain and was surrounded by small shops, a bookstore, and many restaurants.

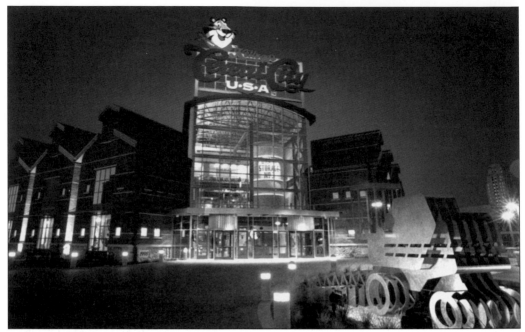

Kellogg's Cereal City U.S.A. opened in 1998 on West Michigan Avenue across the Battle Creek River from the Kellogg Corporate Headquarters. It was funded partially by Kellogg Company retirees and housed exhibits that told the story of the cereal industry in Battle Creek through interactive displays, as well as a simulated cereal production line. The facility was closed in 2007.

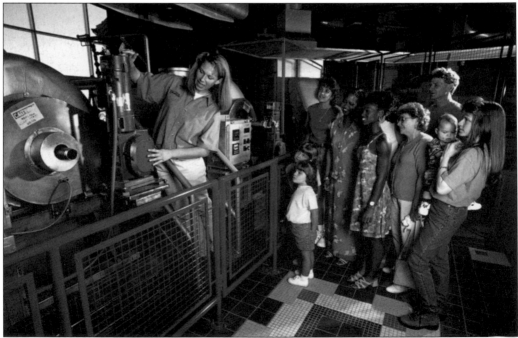

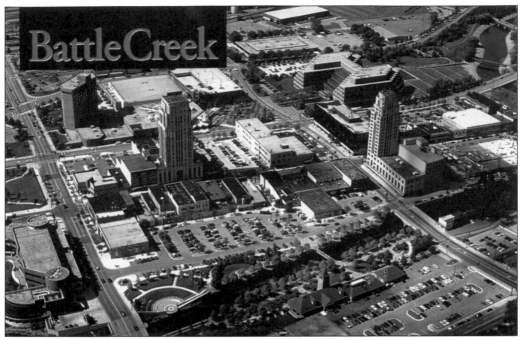

This aerial view from the first decade of the 21st century is looking southwest over the central business district. Some of the buildings are, from left to right, the W. K. Kellogg Foundation building, the McCamly Square complex, the Heritage Tower, the Western Michigan University Kendall Center, the Kellogg corporate headquarters, the Battle Creek Tower, and (near the bottom, along the Battle Creek River and the linear park) Clara's on the River restaurant.

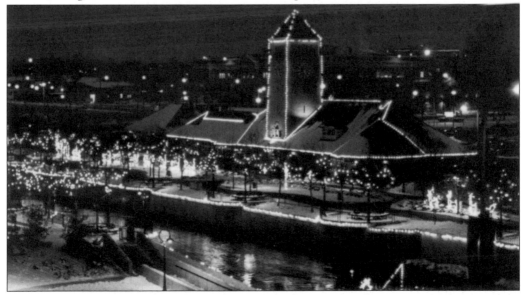

The Festival of Lights began in the winter of 1990. The annual six-week celebration, held annually from Thanksgiving until New Year's Day, features outdoor sculptured lighting and nearly one million lights throughout the downtown area. Among other activities, a "balloon illume" featuring nighttime, tethered, and lighted hot-air balloons is a popularly attended event. This view is of the holiday-lighted Clara's on the River restaurant.

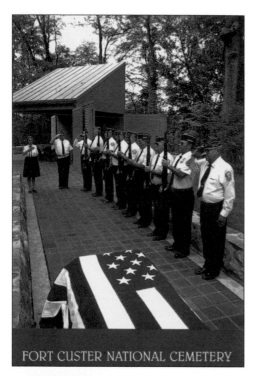

FORT CUSTER NATIONAL CEMETERY

In September 1984, the 150-acre Fort Custer National Cemetery was dedicated by ex–First Lady Pat Nixon. The beautifully wooded site had grown to over 770 acres and by 2005 had 20,656 interments. It is located six miles west of Battle Creek and is named after Fort Custer, the military camp that was built in 1917 to train World War I soldiers and continues to be a military training facility for the Michigan National Guard. The site had served as a burial ground for the military facility since the first interment in 1943, when it was known as the Fort Custer Post Cemetery.

Battle Creek

This 1990s view, looking east from the walking bridge over the Battle Creek River, shows the 15-acre, beautifully landscaped grounds of the Kellogg Company Corporate Headquarters. The five-story, 300,000-square-foot headquarters building was designed by Hellmuth, Obata, and Kassabaum, architects from St. Louis. The $70 million structure was completed in 1986 and features grain motifs in etched glass, wood paneling, leaded glass sidelights, and oak parquet flooring.

Two

GOVERNMENT

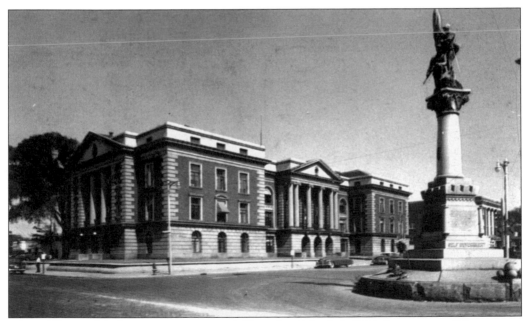

The Soldiers and Sailors Monument was dedicated on March 3, 1901, in memory of the women and men who served in the American Civil War. The Battle Creek City Hall, designed by E. W. Arnold, was opened in 1914. The land and furnishings cost $305,000, causing Mayor John Bailey to complain that the building was too elaborate for Battle Creek and more suitable for a city the size of Detroit. This view of Monument Square was taken in the 1950s.

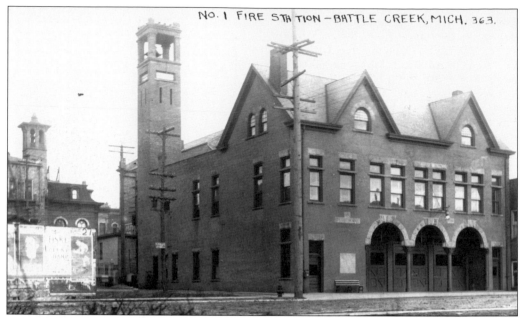

No. 1 Fire Station was built in 1893 facing Jackson Street, behind the old city hall (which can be seen on the left). This building was demolished after a new No. 1 Fire Station was built on East Michigan Avenue in 1972. The old building's capstone and fire bell were removed and are displayed in front of the newer station.

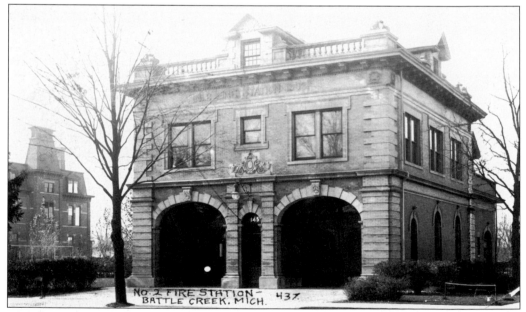

The $9,100 No. 2 Fire Station was built at 145 North Washington Avenue in 1903, after the 1902 fire that destroyed the Battle Creek Sanitarium. Local urban legend tells the story of Dr. John Harvey Kellogg walking past the station where many of his San patients were indulging in forbidden behavior (alcohol and cigarettes). Dr. Kellogg made a disparaging comment about those sinners. Proud of this designation, the San renegades formed a Sinners Club complete with membership cards and a roster of over 300 names.

No. 3 Fire Station was located on the southeast corner of Cliff and Grenville Streets. The fire station was built on land donated by C. W. Post for "civil improvements for the neighborhood and factory" (the Postum Cereal Company was across the street). Hubert Scofield designed this fieldstone building and the very similar No. 4 Fire Station on Kendall Street.

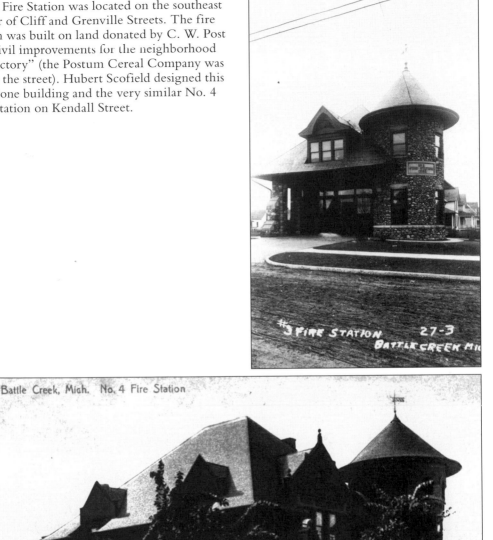

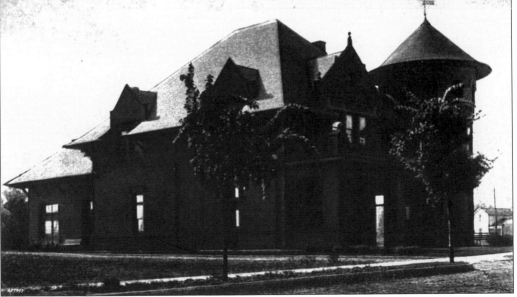

No. 4 Fire Station was built in 1903, at a cost of $8,099. No. 4 Fire Station served Battle Creek for over 75 years at its 175 South Kendall Street location. Architect Hubert Scofield from Chicago designed the Romanesque-style brick building; he moved to Battle Creek in 1900. The station went into service on Saturday, July 2, 1904, with a horse-drawn combination hose and chemical wagon. This was the last city fire station to use horses. It was closed in 1982.

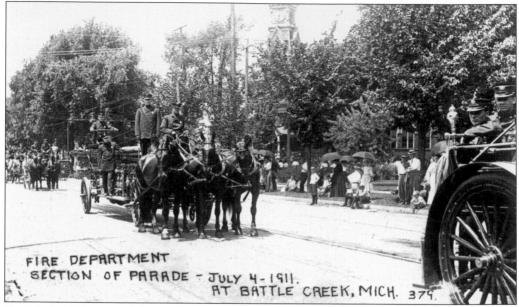

On July 4, 1911, some of the horse-drawn fire equipment from the Battle Creek Fire Department takes part in a parade by McCamly Park. The city's municipal fire service began in 1846 after the Congregational/Presbyterian church burned down on Main Street. The city's first motorized fire truck, called a "Jackson Car," was purchased on July 18, 1911, at a cost of $5,500. The final horse was retired on March 12, 1917. (Courtesy of Carol Bennett.)

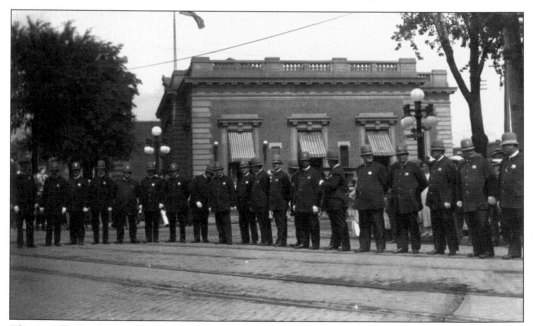

These early-1900s Battle Creek policemen are near the U.S. post office building and appear to be lining up for a parade. The first official law enforcement person in Battle Creek was village marshal Frederick Clarke. On April 30, 1900, the city council authorized the formation of the Battle Creek City Police Department and appointed William H. Farrington as the first chief of police. Chief Farrington was allowed to hire nine policemen. (Courtesy of Carol Bennett.)

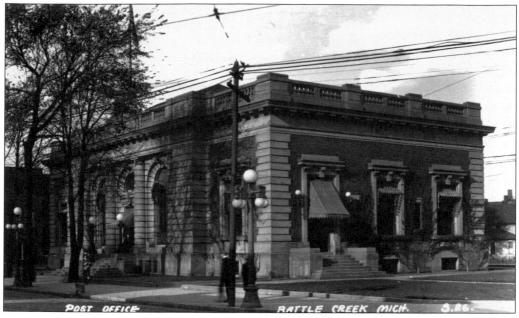

POST OFFICE BATTLE CREEK MICH. 3.26.

In 1904, the young Detroit architect Albert Kahn was selected to design the Battle Creek Post Office. The construction of the Beaux-Arts building was entrusted to Charles Howind of Jackson, Michigan. During construction, there were continual problems acquiring building materials, and delays were frequent. The local newspapers ridiculed the builders, wondering if the post office would ever be finished. The beautiful arched ceiling lobby was put into service on May 7, 1907.

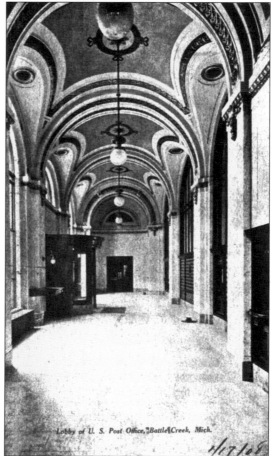

Lobby of U. S. Post Office, Battle Creek, Mich.

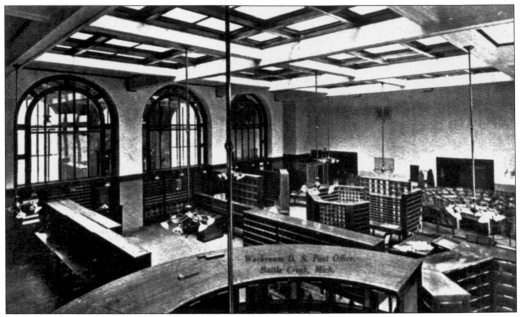

Workroom U. S. Post Office, Battle Creek, Mich.

The mail sorting room of the 1907 building was spacious and lit by a large sky-lighted ceiling. In 1931, an addition to the west of the building was constructed, doubling the size of the structure. In 1968, a new post office building was opened on South McCamly Street. This building was remodeled into the Hall of Justice, housing Calhoun County's circuit and district courts. In the 1980s, the courts moved into the Justice Center on East Michigan Avenue and Jay Street. The building presently houses the Calhoun County visitor and convention bureau, the City of Battle Creek planning department, and the Battle Creek Chamber of Commerce.

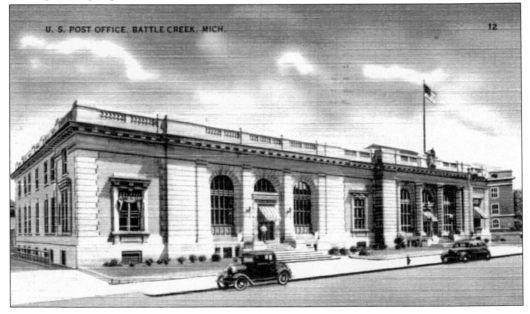

U. S. POST OFFICE, BATTLE CREEK, MICH. 12

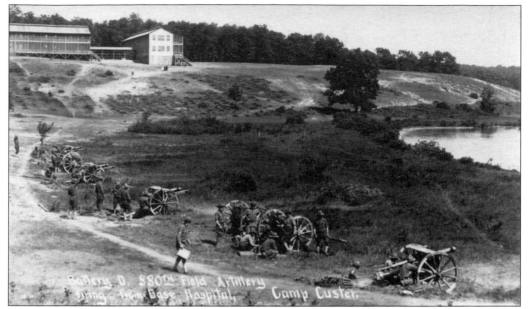

Battery D. 330TH Field Artillery Firing from Base Hospital, Camp Custer.

In 1917, over a five-month period of time, more than 8,000 men working for Porter Brothers Construction Company transformed 100 farms west of Battle Creek into one of the nation's 36 U.S. Army cantonments. The facility was called Camp Custer, named after Brig. Gen. George Armstrong Custer, a Michigan native, and contained 2,000 buildings for 36,000 men at a cost of over $8 million.

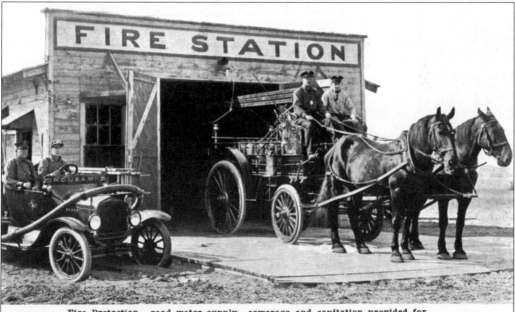

Fire Protection. good water supply, sewerage and sanitation provided for.

The 10,000-acre Camp Custer was a complete, self-sufficient city with its own water and sewer system, central heating plant, hospital, bakery, laundry, theaters, library, and facility to train horses and mules for military service. This image shows one of the camp's horse-drawn firefighting apparatus.

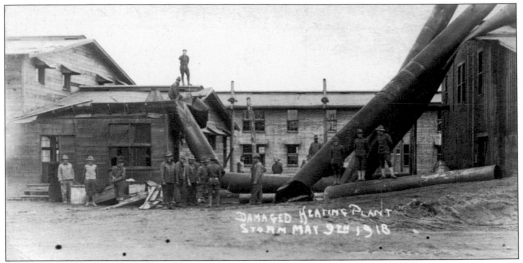

This card, dated May 9, 1918, shows damage to the Camp Custer heating plant's smokestacks caused from a wind storm.

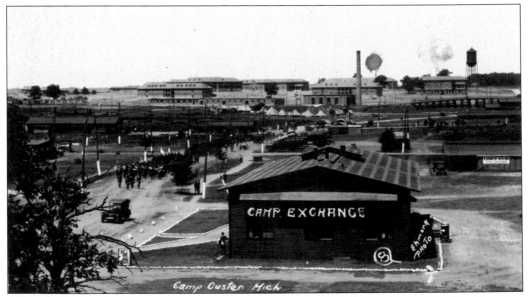

In August 1923, the United States government opened the Camp Custer Veterans Administration Hospital at a cost of $2 million. The 22-building complex, located at the west side of the camp, was the largest health care facility in Michigan. As part of the vocational rehabilitation programs, orchards, a vegetable truck farm, and a poultry/hog farm were available to patients. This view shows the road by the camp exchange leading up to the hospital. (Courtesy of Carol Bennett.)

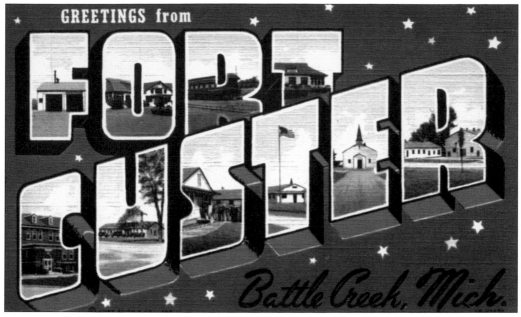

Between World War I and World War II, the camp was used by the Officers' Reserve Corps, Reserve Officers' Training Corps, Citizens' Military Training Camp, and district headquarters for the Civilian Conservation Corps. On July 29, 1940, the camp's name was changed to Fort Custer. Additional land brought the total area to 14,000 acres, and 700 new buildings were added at a cost of $12 million. During World War II, the fort was a processing center for POWs, with more than 4,000 German POW's interred there. This 1940s postcard shows the fort's many amenities.

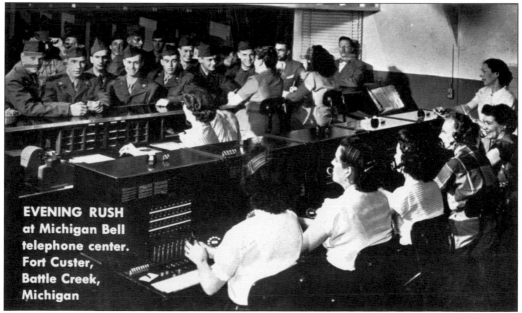

EVENING RUSH at Michigan Bell telephone center. Fort Custer, Battle Creek, Michigan

During World War II, getting a letter from home was very important, but sometimes the soldiers were given the time to make a telephone call from the Fort Custer Michigan Bell Telephone Center. This image shows an evening rush of soldiers attempting to make contact with friends, relatives, and girlfriends.

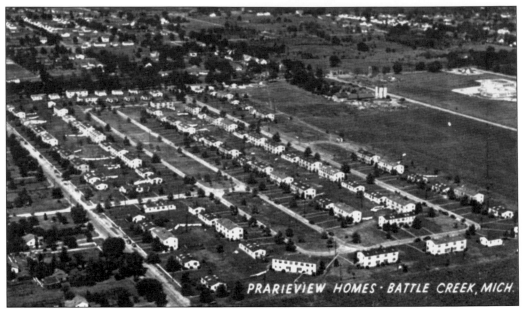

PRARIEVIEW HOMES · BATTLE CREEK, MICH.

Built as temporary housing for officers' families stationed at Fort Custer during World War II, these single and duplex units were built on Twenty-Second and Twenty-third Streets in the Lakeview neighborhood. After the war, they were sold at public auction and are still used as homes and apartments.

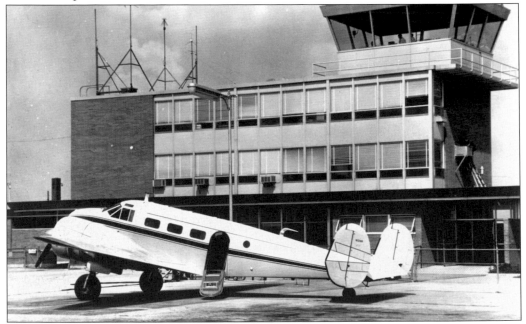

After the end of World War II, the Kellogg Airfield was returned to civilian use. The 172nd Fighter Squadron of the Michigan Air National guard established a base on the northwest side of the airport in 1947. The civilian airport was certified a class 5 airfield, capable of handling the largest land–based aircraft of that time. The Kellogg Airport Terminal was dedicated on December 4, 1958. This 1960s view of the west side of the terminal building shows a Beechcraft Model 18 aircraft ready for flight. (Courtesy of the Alex Fisher Collection.)

Three

HEALTH

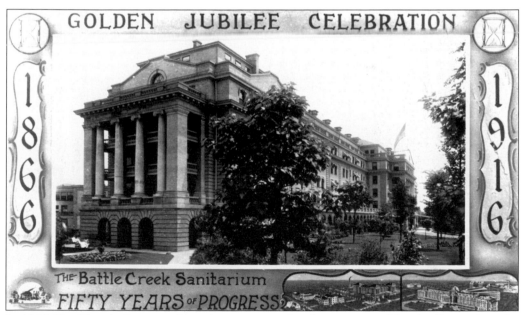

In 1866, Dr. Horatio Lay transformed a two-story farmhouse, west of the city limits, into the Western Health Reform Institute under the auspices of the Seventh Day Adventist Church. Dr. John Harvey Kellogg took charge of the facility and renamed it the Battle Creek Sanitarium to optimize its "sanitary" way of dealing with health issues. The San became very successful and soon became one of the largest health spas in the country. This 1916 postcard celebrates the San's 50th anniversary.

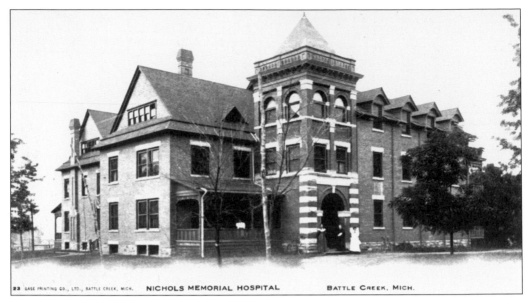

Nichols Memorial Hospital formerly opened on September 17, 1890. A $10,000 donation from John C. Nichols, one of the founders of the Nichols and Shepard Company, helped secure the property that had once been the home of one of the city's founders, Sands McCamly, on Tompkins Street facing the Michigan Central Rail Road tracks. In 1901, an addition was built facing Van Buren Street (as shown on the postcard). The Nichols Memorial Training School for Nurses was constructed across Van Buren Street.

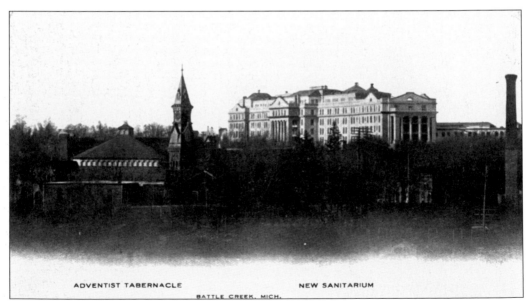

ADVENTIST TABERNACLE NEW SANITARIUM
BATTLE CREEK, MICH.

The original Battle Creek Sanitarium burned to the ground on February 18, 1902. The sanitarium's medical director, Dr. John Harvey Kellogg, was on a train returning to Battle Creek from Chicago when he was informed of the fire. By the time he arrived, he had already drawn up a plan for the new building, and construction began almost immediately. This early-1900s view from Prospect Park (see page 20) looking north shows the Seventh Day Adventist Dime Tabernacle (left) and the Battle Creek Sanitarium.

W. K. Kellogg had been planning to quit working at the Battle Creek Sanitarium to start his own cereal business when the 1902 fire destroyed the sanitarium. He agreed to keep working for his brother Dr. John Harvey Kellogg until the San was financially secure. This view is of the $700,000 building's Washington Avenue entrance that opened in May 1903.

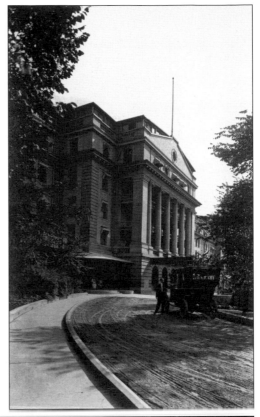

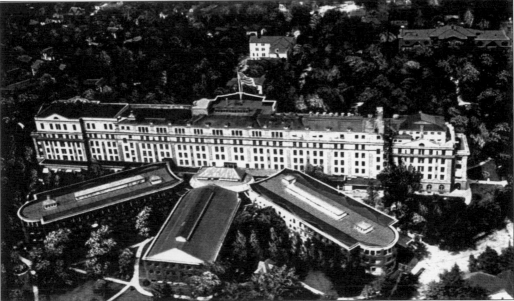

This is an aerial view of the east side (or back) of the 1903 Battle Creek Sanitarium. The 550-foot-long Beaux-Arts facade of the 1,000-patient-room facility had three 120-foot-long wings extending from the building's back. The wings house the hydrotherapy rooms that treated patients with more than 200 types of water therapies and treatments.

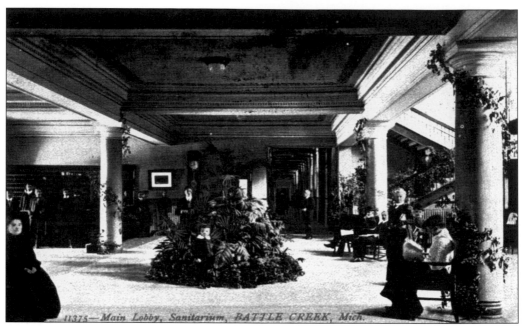

The Washington Avenue main entrance looked very much like a high-class hotel with spacious registration desks, porters, and large ferns. This main floor also contained physician offices and parlors. The kitchens and dining room were on the top floor. Dr. John Harvey Kellogg believed by placing the kitchens on the sixth floor, the cooking smells would not distract the patients on the lower levels.

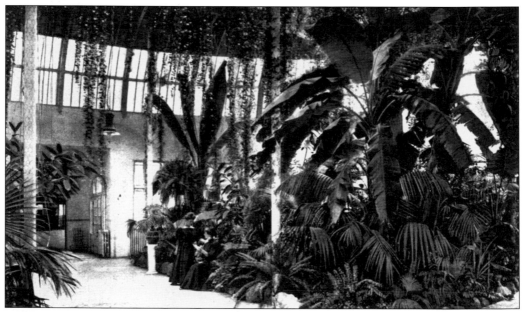

A glass-domed, 60-by-40-foot, semicircular Palm Garden was located at the center of the 1903 building. It was a favorite spot for guests to relax among the rustic waterfall, fishpond, and citrus, rubber, palm, and banana trees while absorbing beneficial sunlight.

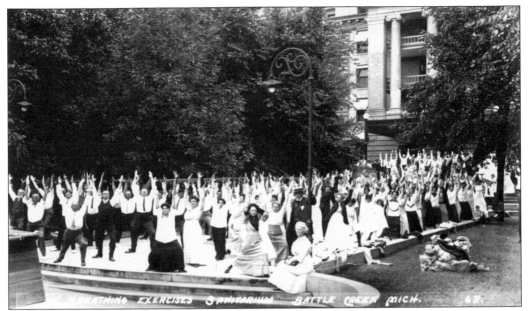

Group exercise in the fresh air was a major part of healthful living that was taught by Dr. Kellogg. This view at the Washington Avenue entrance of the sanitarium has an instructor on a platform (far left edge of the postcard). Music helped patients exercise longer, and it took their minds off the repetition of the activity, so a pianist was usually accompanying the instruction.

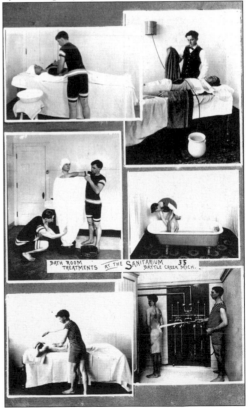

Dr. Kellogg invented many forms of exercise (he personally created one of the first recorded exercise record albums) and developed many types of therapy and inventions to administer them. Some of his inventions included an exercise "stallion," vibrating chairs, electric light therapy, and electrical current therapy, among many others. This postcard demonstrates some of the San's bath room treatments. (Courtesy of Carol Bennett.)

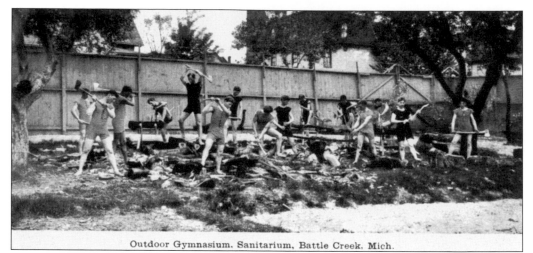

Outdoor Gymnasium. Sanitarium, Battle Creek, Mich.

As part of the exercise regime, the Battle Creek Sanitarium had its male patients chop wood. Not only was it a good way to exercise their arms and expand lung capacity, but also it was a great way for the San to get wood cut up at no charge to the facility.

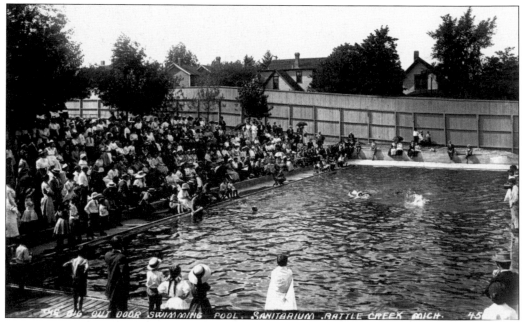

THE BIG OUT DOOR SWIMMING POOL, SANITARIUM, BATTLE CREEK, MICH. 45

The Battle Creek Sanitarium health philosophy included swimming as an excellent form of exercise. There were swimming pools inside the San itself and a large outdoor pool for the patients' use. Tennis courts, bowling alleys, and walking and bike trails were all provided to make getting healthy less tedious.

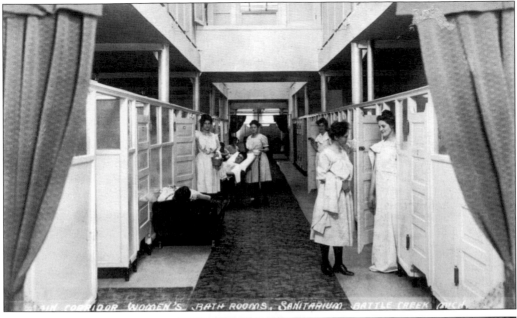

Located in separate male and female wings at the back of the Battle Creek Sanitarium (see page 81) were massage rooms and bath rooms used in Dr. John Harvey Kellogg's treatment for healthy living. Along with hydrotherapy (water therapies), other treatments could include hot and cold wraps, warm ointment fomentations, and compresses. The San employees sometimes worked for no wages (encouraged by Dr. Kellogg), just for the honor of serving in the battle against poor health.

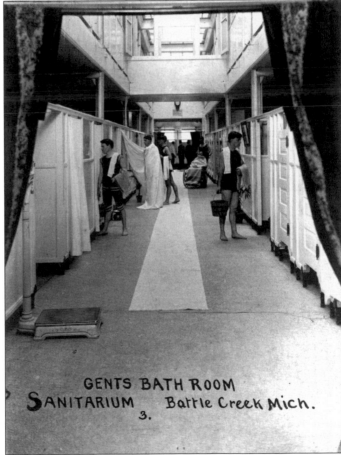

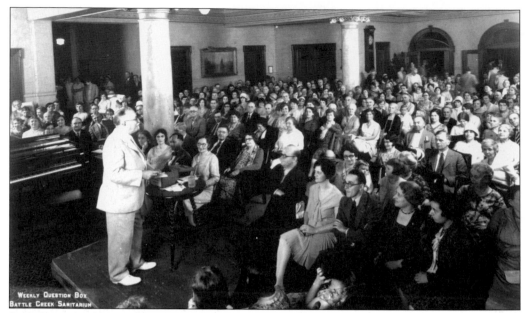

Dr. John Harvey Kellogg enjoyed presiding over each week's "question box" session. Throughout the week patients were encouraged to write down their health and medical questions and place them in a box kept in one of the parlors. Once a week, Dr. Kellogg would answer the patients' inquiries. As the years went by, Dr. Kellogg believed that the human body needed light to be healthy, and he dressed entirely in white, thinking it was the most advantageous way to get light to his skin.

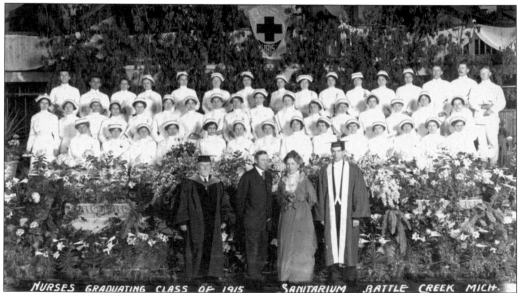

Student nurses received practical experience while studying in the Battle Creek Sanitarium Hospital Training School. Part of their medical education at the San was provided by the Battle Creek College, located across Washington Avenue from the San. The college was established by Dr. Kellogg on January 4, 1875. In 1895, it was renamed the American Medical Missionary College. This postcard shows Dr. Kellogg standing in the front row (on the far left) of the nurses graduating class of 1915. (Courtesy of Carol Bennett.)

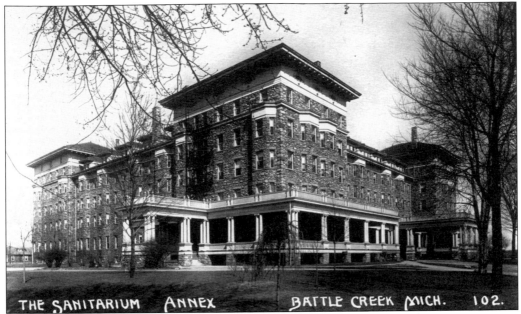

THE SANITARIUM ANNEX BATTLE CREEK MICH. 102.

In 1900, Neil Phelps built the largest fieldstone structure in the United States. The $250,000 Phelps Medical and Surgical Sanatorium, located on Washington Avenue, was opened to compete with the nearby Battle Creek Sanitarium. Phelps's sanatorium went bankrupt in 1904, and then C. W. Post purchased the building and leased it to Bernarr MacFadden. In 1913, it was purchased by the Battle Creek Sanitarium to be used for overflow patients when there were no rooms available in the main building. It also housed some of the San's employees.

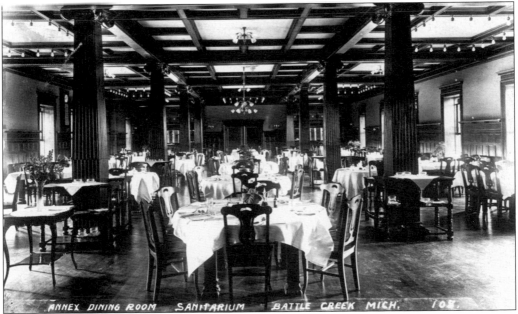

ANNEX DINING ROOM SANITARIUM BATTLE CREEK MICH. 108.

The Battle Creek Sanitarium Annex dining room is shown in the second decade of the 20th century. In 1942, the main building of the San was sold to the United States government. Dr. Kellogg moved his health facility to the annex. The building was demolished in 1986.

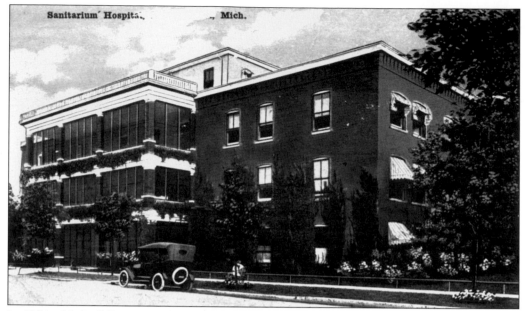

In 1901, this building was constructed as the Sanitas Nut Food Company to replace a cereal factory that burned down in 1899. It was built to be fireproof and strong; the outside walls were 22 inches thick, and the floors were four-inch-thick Portland cement with woven wire, resting on steel beams at six-foot intervals. In 1914, it was converted into a surgical hospital annex to the main Battle Creek Sanitarium and was supplied heat from the main building by a connecting tunnel.

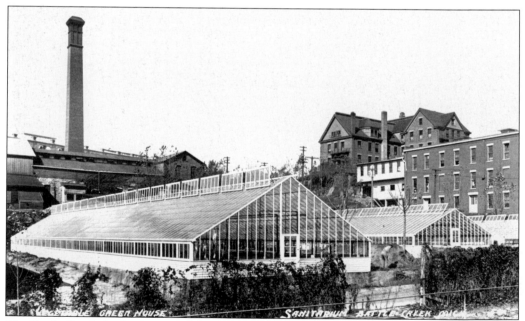

The Battle Creek Sanitarium used its own private orchards, dairy, and farm to supply its patients with fresh produce. The smaller greenhouses behind the main building were used for growing flowers and scientific experiments being researched at the San. (Courtesy of Carol Bennett.)

Against the wishes of Dr. John Harvey Kellogg, the Battle Creek Sanitarium's board of directors decided to build a large, extravagant addition to the San, to attract more financially affluent patients. The 15-story "Towers" section was designed by Chicago architect M. J. Morehouse.

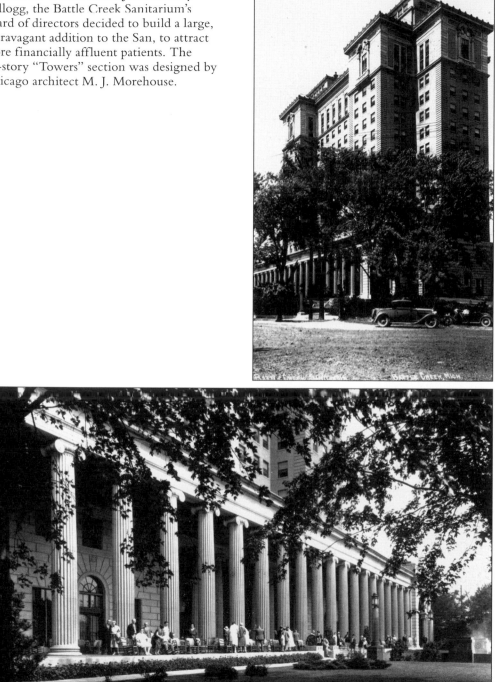

The two-story front porch colonnade greeted Henry Ford, in 1928, when he signed the guest registry as the first patient in the new section. The Towers' 600 patient rooms were furnished by Marshall Fields of Chicago. Pres. William Howard Taft was the San's 100,000th guest. Other famous patients included Eleanor Roosevelt, J. C. Penny, S. S. Kresge, and Amelia Earhart.

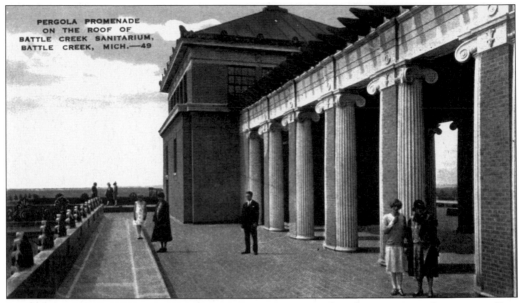

The Battle Creek Sanitarium's Tower rooftop was a popular place to view the surrounding countryside and a location for fresh air and exercise. The cost of the entire Towers addition was over $3 million.

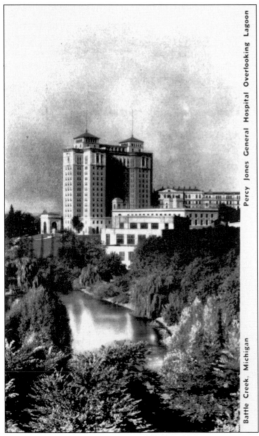

The Battle Creek Sanitarium built the Towers addition in 1928. When the Great Depression arrived, it made a visit to the San an expensive luxury. As time went by, the San sank into bankruptcy, and it was sold to the United States government and became Percy Jones Army Hospital. This view of the hospital from the east shows the buildings' proximity to Irving Park and its restful lagoons.

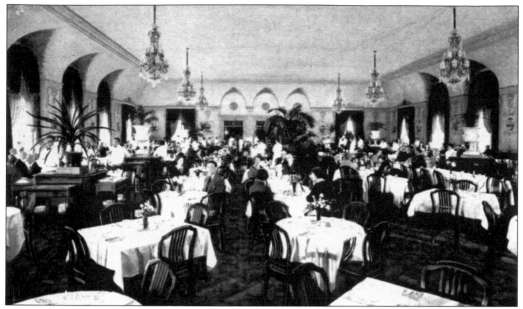

The main dining room of the 1928 Battle Creek Sanitarium had 10,000 square feet of space, making it the largest dining area in the world with no visible ceiling support columns. There were 24 hand-painted murals decorating the walls, and eight Czechoslovakian lead crystal chandeliers with 100 lightbulbs in each lit the room.

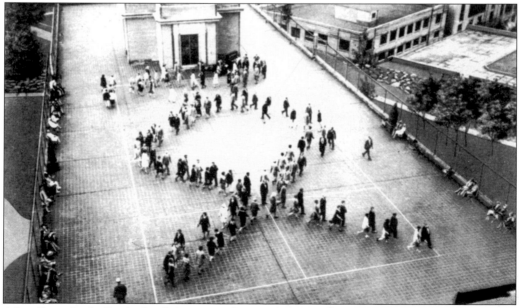

After dinner in the Battle Creek Sanitarium's main dining room, many of the patients participated in a "Grand March," or in later years it was called the "Hop at the Top," on the 15,000-square-foot, red-tiled roof. Not only was it a fun social event, it was fresh air and exercise.

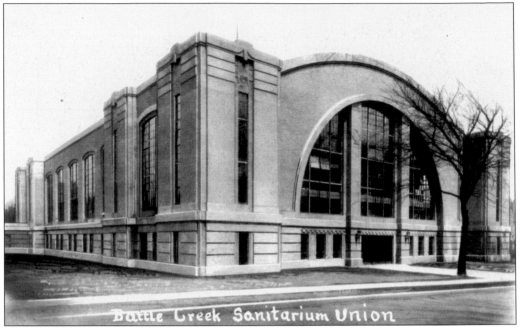

Battle Creek Sanitarium Union

The art moderne Battle Creek Sanitarium Union building was constructed in 1928 as a recreational facility for San employees. It is located on the northwest corner of Champion and Brook Streets. Designed by Chicago architect M. J. Morehouse, it contained a swimming pool, locker rooms, and a large gymnasium that could be modified into a 5,000-seat auditorium. The United States government purchased the building and used it as a physical therapy unit for Percy Jones Army Hospital. In 1958, it was declared surplus property and sold to the Battle Creek Public Schools for $1 and remodeled into the Battle Creek Central High School Field House.

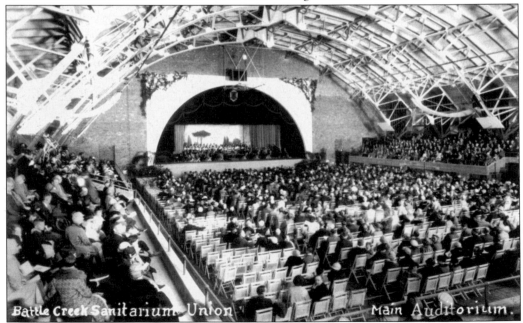

Battle Creek Sanitarium Union Main Auditorium.

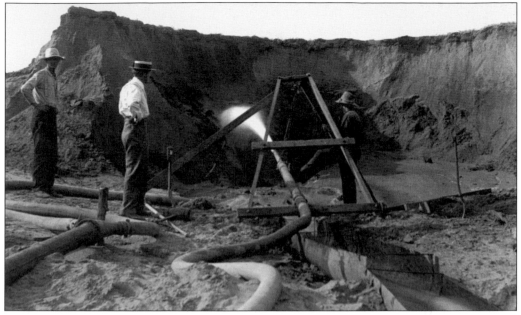

Harlan K. Whitney purchased swampland near the intersection of what is now North Avenue and Emmett Street. Starting in December 1912, he began using hydraulic hoses, pumping water, and washing away the sandy hills into the swamp area. When they had finished, they had graded 25 acres of land and had moved 125,000 yards of earth. In 1926, the area became the site of Leila Y. Post Montgomery Hospital.

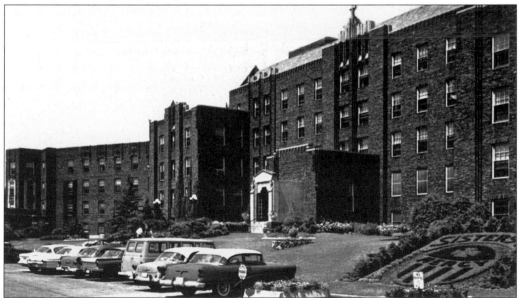

Located on the northeast corner of North Avenue and Emmett Street, Leila Y. Post Montgomery Hospital had its formal dedication on April 19, 1927. The 80-bed hospital was a donation by C. W. Post's widow as a gift to the city. In 1929, the west wing was added, bringing the bed count to 128. The Weinstein Lodge housed the Leila Hospital School of Nursing and later became known as Leila Lodge. In 1967, at a cost of $7.5 million, a 227-bed addition was constructed, opening for patients in 1970.

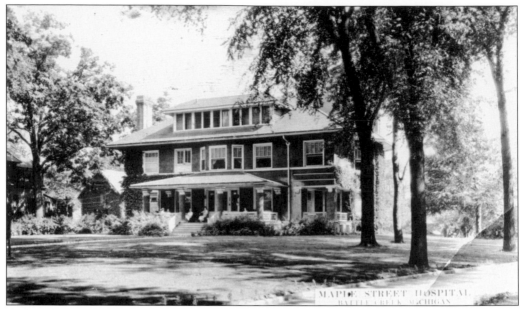

Sumner Bush, the vice president and general manager of the Advance Thresher Company, built this home on Maple Street (now Capital Avenue NE) in 1907. It was later used as the Maple Street Hospital, and then in 1940, it was remodeled to be used as a YMCA. The structure was demolished in 1971 to make room for the present Family Y-Center.

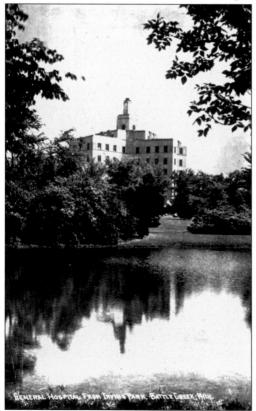

Nichols Memorial Hospital on Van Buren Street was no longer large enough to meet the needs of the ill and injured of Battle Creek. In 1929, land was acquired between West and Brook Streets by the Battle Creek General Hospital Association as a site to build a hospital. Construction began in 1931, but because of financial difficulties brought about by the Great Depression, Community Hospital was not completed until 1938. This 1930s view is of the hospital building reflected in an Irving Park Lagoon. (Courtesy of Carol Bennett.)

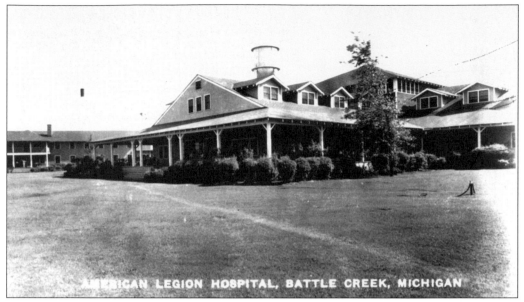

The Roosevelt Community House on Evergreen Road at Camp Custer was dedicated by Ferdinand Foch, the supreme commander of the Allied Forces during World War I. On October 27, 1921, the building was turned over to the American Legion Hospital. A tuberculosis wing was added in 1954. In the 1960s, the facility began specializing in long-term rehabilitation. It later evolved into Southwest Michigan Rehabilitation Services. The two-story, rustic lobby view of the building from the second decade of the 20th century calls it the International Health Resort. (Above, courtesy of Carol Bennett.)

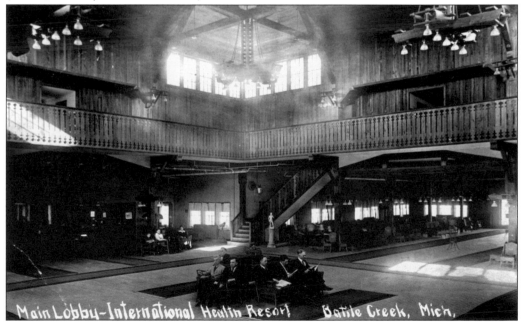

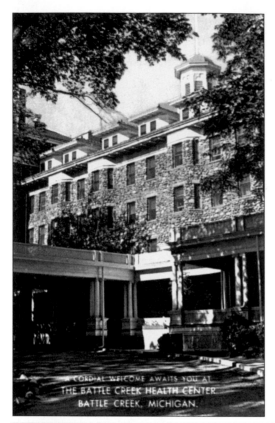

Because of the financial difficulties brought about by the Great Depression, the fieldstone Battle Creek Sanitarium Annex became the main facility for Dr. John Harvey Kellogg when his large facility on the northeast corner of Champion Street and Washington Avenue had to be sold to the United States government. It was the largest fieldstone building in the United States when it was demolished in 1986. This 1960s postcard welcomes patients to the Battle Creek Health Center.

The Jeffrey's Building, located on the northwest corner of Washington Avenue and Manchester Street, was opened on January 11, 1971. It was named for James R. Jeffrey, the second medical director of the Battle Creek Sanitarium after Dr. Kellogg's death. The four-story brick hospital was acquired by Battle Creek Health System and is now known as the Fieldstone Center.

Four

EDUCATION

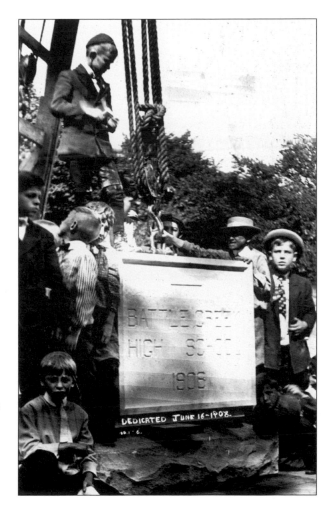

The cornerstone for Battle Creek High School (now Battle Creek Central High School) was set in place on June 6, 1908. A parade preceded the dedication ceremonies that were conducted by local dignitaries and Masonic Lodge members. A time capsule was placed in the cornerstone. The architect's drawing of the school is on page 101.

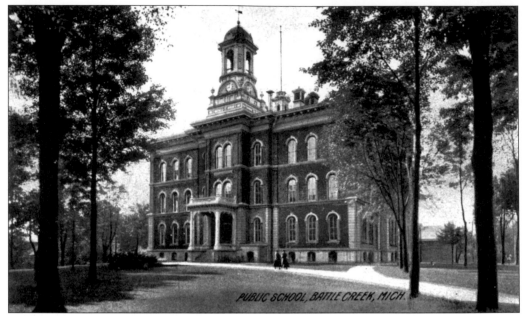

On April 10, 1871, No. 1 school (the school buildings were numbered, not named) opened on McCamly Street on the site of the first Union Schoolhouse. The building cost $75,000 to construct and contained a natural history museum (which eventually evolved into Kingman Natural History Museum). When the new high school opened in 1909, this building became the city's first junior high school.

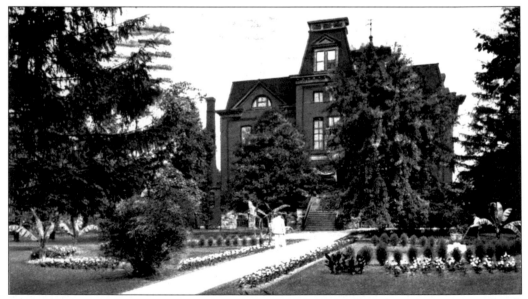

Battle Creek College was opened on January 4, 1875, by the Seventh Day Adventist Church directly across Washington Avenue from the Battle Creek Sanitarium. The three-story brick structure cost $30,000, and two additions were built in 1886 and 1893. The school changed its name to the American Medical College in 1895. In 1923, Dr. John Harvey Kellogg's Schools of Nursing, Home Economics, and Physical Education were merged into Battle Creek College. The school had financial difficulties, and the last class graduated in 1938.

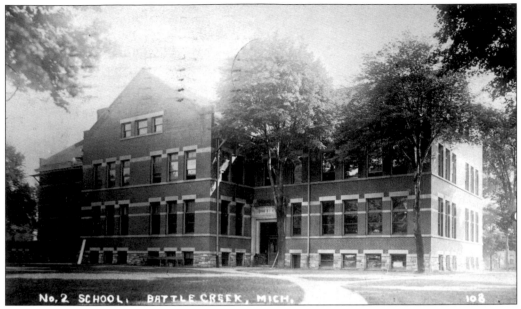

In 1903, this second school building on the Green Street site was the No. 2 school. The school had a capacity of 225 students. The school was renamed Franklin Elementary School in the 1920s after Benjamin Franklin. In 1978, a new Franklin School was built on the northwest corner of Main and Newark Streets. The old school was demolished, and the area is now called Stellrecht Park, named after Sam Stellrecht, a retired director of the Battle Creek City Planning Department.

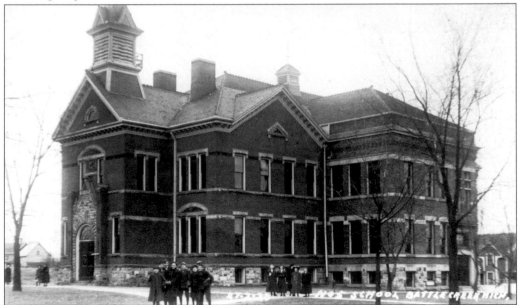

McKinley Elementary School was built in 1889 and originally known as No. 5 school. The building, on the southeast corner of Maple Street (now Capital Avenue NE) and Union Street, was designed by A. D. Ordway. It was enlarged in 1901 and 1902. In 1974, the original structure was replaced by a new school building. The 1950s gymnasium section was reused. The Salvation Army now occupies the building.

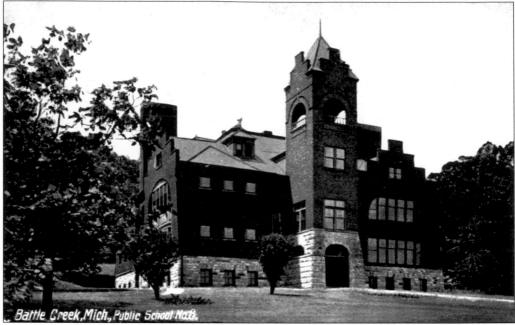

This was No. 8 school when it was constructed in the 1890s at 41 Prospect Street. A new school building was built in 1936 when the school was known as Wilson Elementary School, named for Pres. Woodrow Wilson.

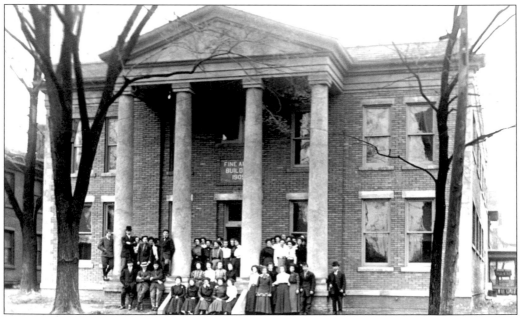

The three-story brick veneer School of Applied Arts building was opened in 1910. It was a correspondence school for art, drawing, and commercial art. It occupied the premises until 1919 when the Battle Creek public schools purchased the property to use as exhibit space for the school's natural history museum that had been organized by Edward Brigham. In 1932, the natural history collection was moved to Kingman Museum in the Leila Arboretum. St. Philip Catholic School converted the building to classrooms and a social hall in 1937.

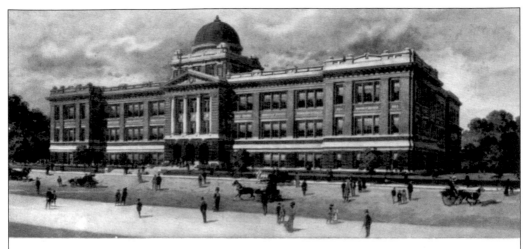

New High School Building, Battle Creek, Mich.

With Compliments of L. A. DUDLEY COMPANY, 6 West Main St.
FINE FOOT WEAR.

This is Ohio architect Wilbur Thoburn Mills's drawing of Battle Creek High School (later called Battle Creek Central High School). The school, located at 100 West Van Buren Street, opened in September 1909. The school building included a celestial observation dome that was removed during the 1940s. The three arched front doorways led to a wide, white marble central staircase that was flanked by two large murals depicting Native American scenes. The building contractor was S. B. Cole. A local shoe business proudly used the new school building in its advertising.

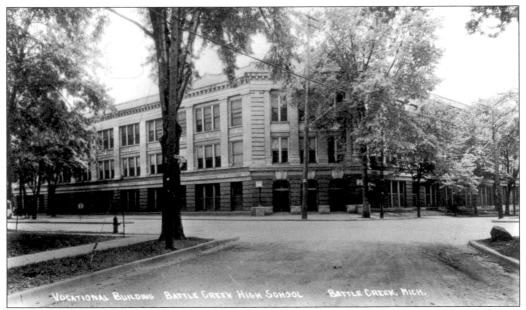

The Battle Creek Central High School vocational building, facing West and Champion Streets, was designed by J. D. Chubb. The 1922 structure specializing in industrial, business, and mechanical arts was connected to the main high school building by a second-floor enclosed bridge. A large three-story staircase is covered by a stained-glass skylight.

101

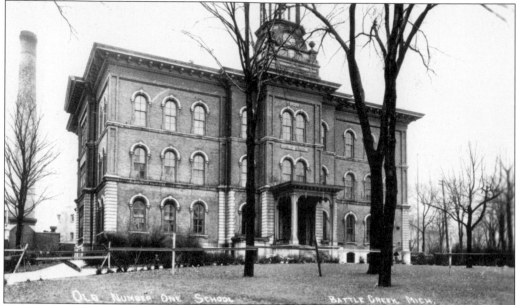

In 1934, old No. 1 school was demolished and the area was used as an athletic field for the schools. The school was opened in 1871. After the opening of the Van Buren Street Battle Creek High School, this building became the city's first junior high school. In 1934, W. K. Kellogg Junior High School and Auditorium opened across McCamly Street. This postcard shows the bell tower already being torn down, and a fence has been set up to keep people away from the demolition site. (Courtesy of Carol Bennett.)

The central section of this building was the original Lakeview School when it opened on September 19, 1921, at a cost of $150,000. The structure was enlarged in 1921 and 1927. When a new high school was built in the 1940s, the name was changed to Highland Junior High School. The school was demolished in 1983, and a marker on the northwest corner of Columbia and Highland Avenues commemorates the school's former location.

No. 14 school was opened in 1925 and named Fremont Elementary School. It was located on the north block bordered by Fremont, Emmett, and Central Streets. The $255,882 building contained 12 classrooms, an auditorium-gymnasium, and a large kindergarten classroom by the school's front doors.

In 1931, the W. K. Kellogg Foundation donated $245,000 to the Battle Creek public schools to develop education facilities to serve both handicapped and able-bodied students. It was an early example of mainstreaming children. The school was built on the site of the 1861 No. 3 school and named after W. K. Kellogg's mother, a pioneer Michigan teacher. Ann J. Kellogg Elementary School was designed by Detroit architect Albert Kahn.

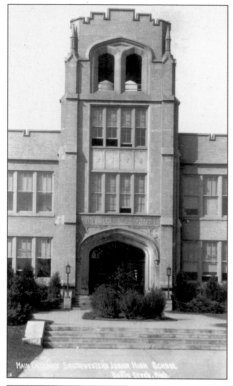

Southwestern Junior High School was opened on January 4, 1928, on the block bordered by Goguac and Ravine (now South Washington Avenue) Streets and Battle Creek Avenue. The $648,000 school contained a 1,200-seat auditorium, separate girls' and boy's gymnasiums, and 29 classrooms. It was the first school building in the city built specifically as a junior high school.

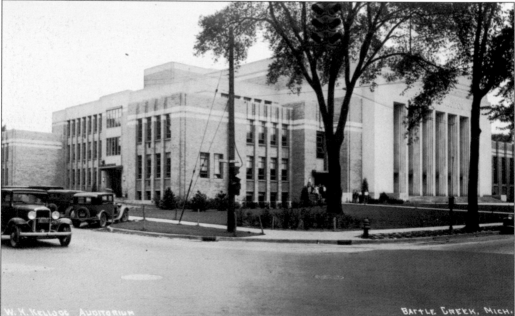

On September 18, 1933, W. K. Kellogg Junior High School and Auditorium were presented as a $700,000 gift to the city from W. K. Kellogg. Detroit architect Albert Kahn designed the international-style building. The junior high school replaced old No. 1 school. The auditorium section of the building originally seated over 2,000 people and contains an Aeolian Skinner pipe organ. The auditorium was renovated in 1981 and 2007. (Courtesy of Carol Bennett.)

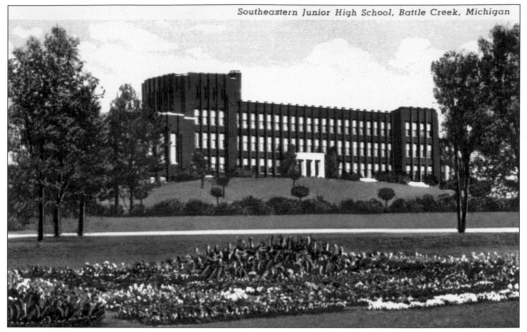

Southeastern Junior High School, Battle Creek, Michigan

Land for a school building was purchased across Porter Street from the Kellogg Company factory. Southeastern Junior High School was designed by Detroit architect Albert Kahn and opened in 1932 with a capacity for 700 students. An auditorium addition was completed in 1957. The school building now houses South Hill Academy.

The first Seventh Day Adventist parochial school was founded in 1872. The original school occupied a portion of the Battle Creek College building until 1904, when an academy for elementary and secondary students was built on North Kendall Street. On September 8, 1948, they opened this Battle Creek Academy school building on Limit Street.

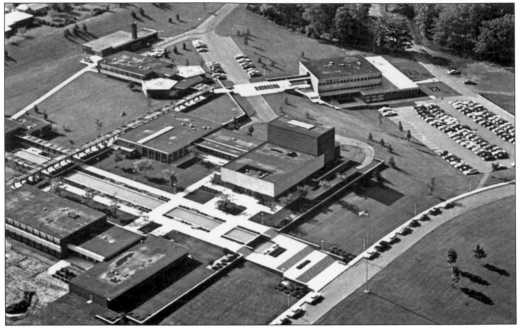

Originally founded in 1956 in the old GAR hall behind Battle Creek Central High School, Battle Creek Community College opened with an enrollment of 94 students. The Battle Creek community supported the school with 23 individual and commercial firms establishing college scholarships in the first year. By 1959, the enrollment had increased to 350. The Battle Creek Public Schools had purchased land in Kolb Park as a site for the college in 1958 and began construction of the classroom-administration building. It was anticipated that the construction would take 12 years to finance and complete. In 1959, the W. K. Kellogg Foundation made a $2 million grant toward the project. At that time, it was the largest single grant the foundation had ever made. The college, located on North Avenue, was dedicated on May 20, 1962, and named Kellogg Community College. (Below, courtesy of the Alex Fisher Collection.)

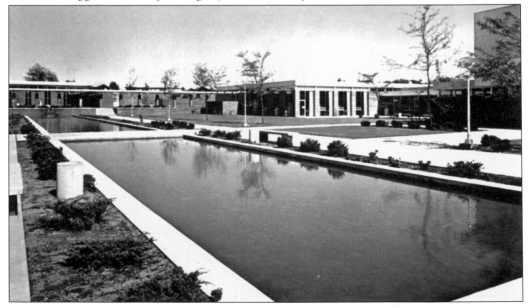

Five

RELIGION

This postcard shows the Battle Creek Central High School's 1967 A Cappella Choir at the pulpit of the 1928 First Presbyterian Church. The choir made the postcards to give away as souvenirs while traveling in Europe to participate in the Koor-festival in The Hague, Holland. The choral group, under the direction of Alfred G. Richards, received the highest score ever attained in that competition. It was also the first American choir to sing in Westminster Abbey in London.

The first documented Catholic service in Battle Creek was a marriage performed in 1847 by a priest from Ann Arbor. The first permanent Catholic church building was a small frame building located on the northeast corner of Maple (now Capital Avenue NE) and Van Buren Streets, which was purchased in 1860 from the Quakers. In 1878, this brick church building was constructed and enlarged in 1902 and 1914. That building burned in 1928, and a new church designed by local architectural firm of Chute and Chanel was completed in 1930.

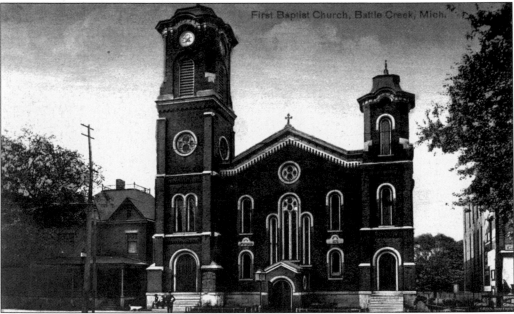

The First Baptist Church, designed by architect William K. Loughborough, was dedicated on June 23, 1872, at a cost of $26,500. The brick building with a Joliet marble foundation is of Norman design. The top of the northeast tower was removed in 1899 after it was struck by lightning. In 1896, the Willard Addition was constructed on the east (left) side of the building to house the parsonage and church offices.

Built on the southeast corner of Van Buren and Maple (now Capital Avenue NE) Streets, St. Thomas Episcopal Church's cornerstone was put in place on July 4, 1876. The English Gothic building was designed by Detroit architect Mortimer Smith. The redbrick structure with Berea–cut limestone trim and buttresses was consecrated in 1878.

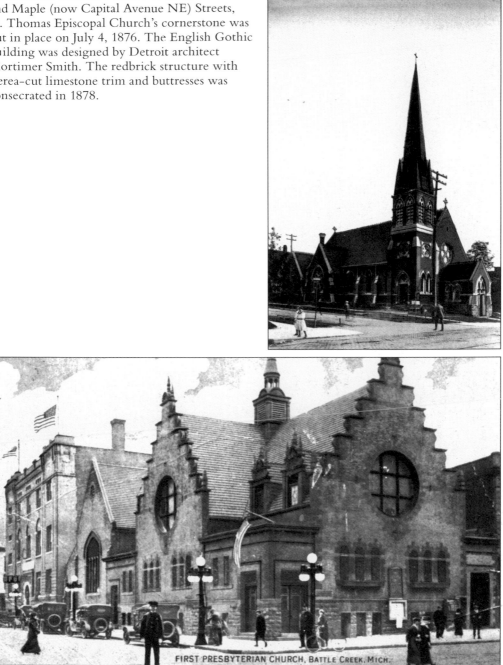

This First Presbyterian Church was built on the northeast corner of McCamly and Main (now West Michigan Avenue) Streets in 1883. A feature of this building was the bare electric lightbulbs that lit the sanctuary. The church contracted an electric firm to check for burned-out lightbulbs each month. The structure was demolished in 1928 when the congregation moved to its Capital Avenue NE location designed by local architect and church member A. B. Chanel.

The first Seventh Day Adventist church in Battle Creek was located on Cass Street. In 1878, the church held a worldwide fund-raising drive to construct the Battle Creek Seventh Day Adventist Tabernacle on Washington Avenue. Contributors were each asked to send one dime to pay the $26,000 construction cost. From that time forward, the church was known as the Dime Tabernacle. The auditorium had seating for over 3,000 people and was dedicated on April 20, 1879. On January 7, 1922, the tabernacle burned to the ground. (Below, courtesy of Carol Bennett.)

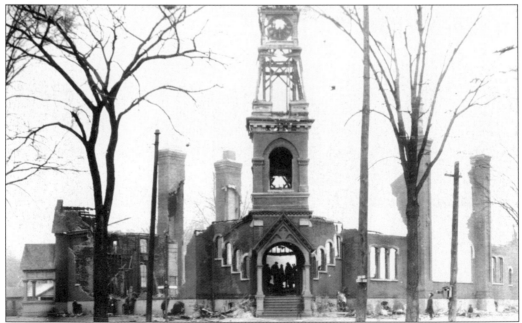

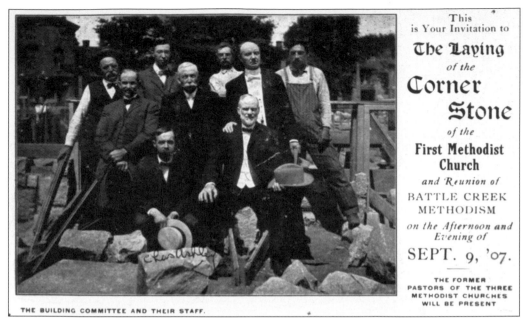

This is Your Invitation to

The Laying

of the

Corner Stone

of the

First Methodist Church

and Reunion of

BATTLE CREEK METHODISM

on the Afternoon and Evening of

SEPT. 9, '07.

THE FORMER PASTORS OF THE THREE METHODIST CHURCHES WILL BE PRESENT

THE BUILDING COMMITTEE AND THEIR STAFF.

This postcard was an invitation to the community for the laying of the First Methodist Church's cornerstone held on September 9, 1907. The original church building on this site (see page 2) was opened in 1860. The new structure was designed by Ohio architect Wilbur Thoburn Mills, who also planned Battle Creek High School (see page 101).

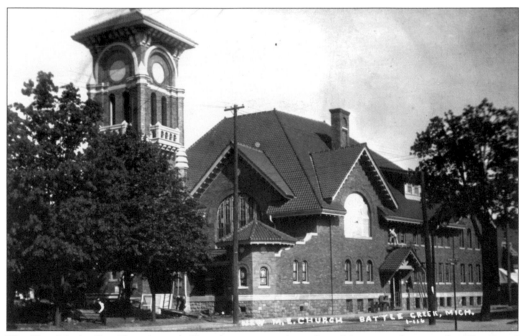

The First Methodist Church was still under construction when this postcard was made. The Good Shepherd stained-glass window had not been placed in the window opening facing Monument Square (see page 2). The 1,200-seat, Romanesque-style church was dedicated in September 1908. The clock was not installed in the tower until funds could be raised in 1911.

This view from the second decade of the 20th century is of the Battle Creek Christian Science's first church edifice, located in the old Kingman Home on the northern corner of Adams and Maple (now Capital Avenue NE) Streets. After months of remodeling the residence into a suitable auditorium, the first service was held in October 1906. In 1928, it moved to a new building, designed by local architect A. B. Chanel, on the southeast corner of Maple and Penn Streets. The old church was demolished, and Farley Funeral Company built its funeral home on that site.

A fire destroyed the previous St. Philip Church building (see page 108) in 1928. Some of the stained glass, altar, and stations of the cross were used in the new church designed by local architects Chute and Chanel. The Romanesque-style church, on the northeast corner of Capital Avenue NE and Van Buren Street, used yellow Bedford limestone and was completed in 1930 at a cost of $200,000.

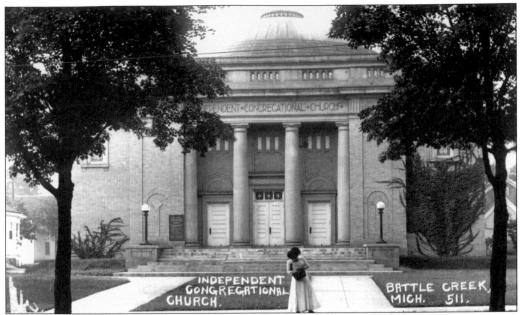

Chicago architect Joseph Llewellyn designed the First Congregational Church building in 1907. Llewellyn also planned Willard Library, Post Elementary School, Post Cereal's factory office, and many local residences. The church building features classically styled brick with limestone trim, simple Doric freestanding columns at the entrance, and a dome rising from a square base that is reminiscent of the Pantheon in Rome.

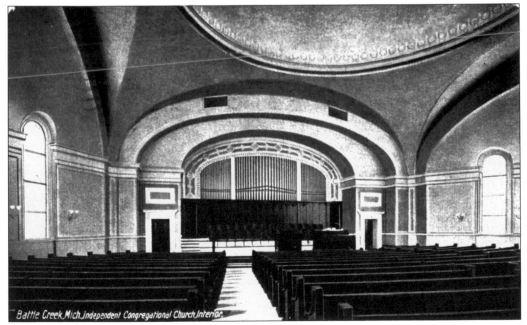

First Pilgrim Holiness Church - Battle Creek, Michigan

The First Pilgrim Church was built at 813 Capital Avenue SW in the 1950s. It was eventually occupied by the First Wesleyan Church. The building was demolished in 1988 and replaced by Ryan's Steak House restaurant in 1989.

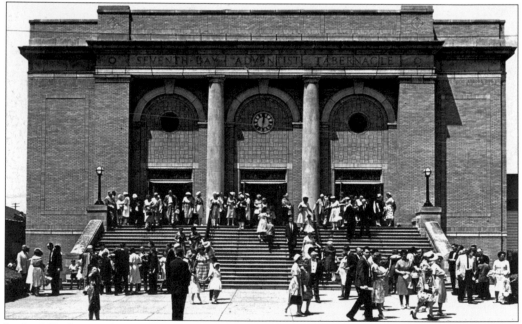

In the fall of 1926, the new Seventh Day Adventist Tabernacle, located at 19 North Washington Avenue, was dedicated to replace the church that had burned in 1922 (see page 110). Local architect A. B. Chanel designed this brick, concrete, and iron building to be totally fireproof, at a cost of $150,000.

Six

PEOPLE AND EVENTS

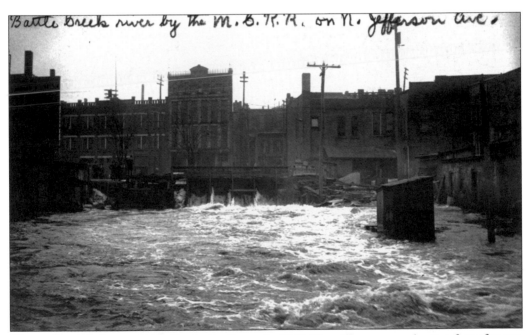

The earliest flood recorded in Battle Creek was in 1852. The village was under two feet of water, and the railroads were unusable. A flood in March 1904 lasted nearly a week. The worst occurred on Easter weekend in 1947. All these events led to the Kalamazoo Flood Control Program in 1948, when the first walls and dikes were constructed. This postcard from the early 1900s shows the millrace flooding the area near the northeast corner of Jackson and Jefferson Streets.

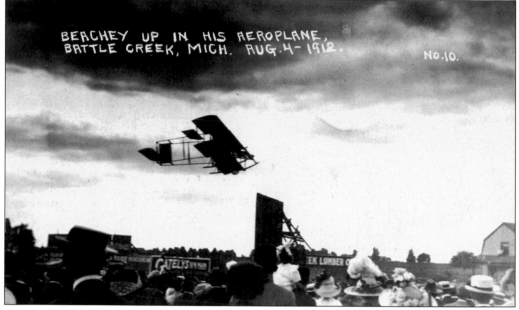

On April 4, 1912, a pilot named Beachey flew his aeroplane at the Athletic Park near Goguac Lake. Heavier-than-air flying machine flights were still a novelty, and crowds came to watch the relatively new inventions. On September 24, 1924, the Battle Creek Chamber of Commerce convinced the city to lease the Garret Wells farm on Territorial Road to create an airport, now the site of W. K. Kellogg Regional Airport.

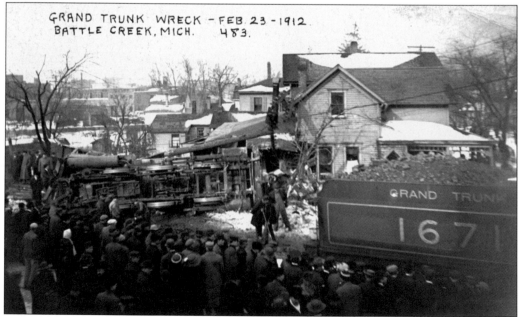

According to the *Battle Creek Enquirer*, on February 23, 1912, this Grand Trunk Railroad steam engine "broke a tire on one of its drive wheels" and somersaulted into the home of Joseph Kavasch on River Street. The brakeman Joseph McAnn was injured. Mrs. Kavasch was treated for shock.

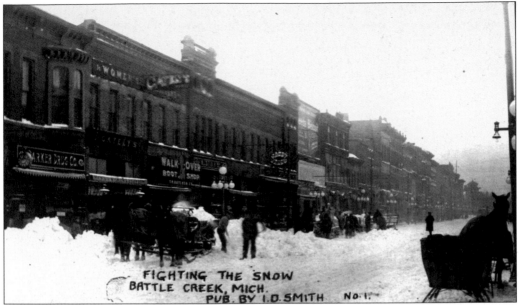

This postcard shows the north side of Main Street (now West Michigan Avenue) during the February 1912 snowstorm that paralyzed downtown Battle Creek for days. Before modern powered snow removal equipment, citizens had to clear the snow with hand shovels.

The February 1912 snowstorm also affected residential areas. This snowy view of the north side of Maple Street near the corner of Fremont Street looking north shows the William Skinner home (left) and the Edwin C. Nichols home. The Skinner home was built in the 1860s. Some history records state that it was a stop on the Underground Railroad. The Nichols home was built in the late 1800s. Nichols worked for his father and founder of Nichols and Shepard, John C. Nichols. His home was demolished in the 1950s.

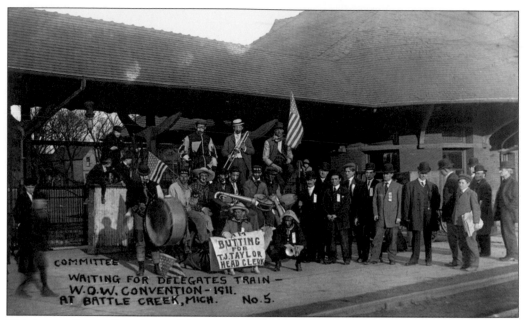

This is one of many Woodmen of the World (WOW) convention postcards made of their festivities in 1911. The WOW was founded as a fraternal organization in Omaha, Nebraska, in June 1890 to establish financial security for its members and assist local communities in need. This image shows the WOW members greeting delegates at the Michigan Central Station (now Clara's on the River). (Courtesy of Carol Bennett.)

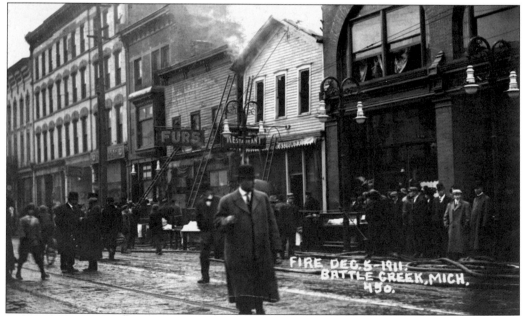

This fire occurred on December 5, 1911, in the Maine Restaurant, located on the south side of Main Street (now East Michigan Avenue) near Monroe Street (now the site of Millrace Park). The cause of the fire could not be determined, but the restaurant chef left town after the fire and could not be interviewed. Almost $12,000 in damages was reported for the restaurant and the Sugar Bowl (a candy shop) located next door. (Courtesy of Carol Bennett.)

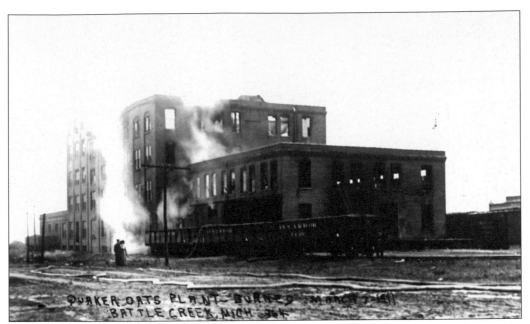

On March 7, 1911, the Quaker Oats Factory on Spencer Street, near Porter Street, had a fire, which began in a food bin on the fourth floor. The damages were estimated at $100,000. The factory was rebuilt, and in April 2, 1923, it was purchased by the Kellogg Company. (Courtesy of Carol Bennett.)

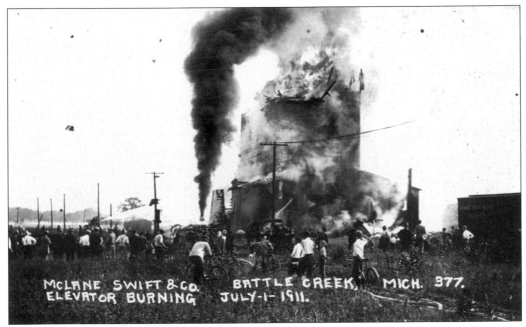

The McLean Swift Company Elevator (grain storage silo) on the corner of Willis and Bartlett Streets near the Grand Trunk Railroad tracks burned on July 1, 1911. The storage facility was rebuilt on Stiles Street. The president of the McLean Swift Company was Theo Swift, with Ambrose Minty as vice president and A. K. Zinn as treasurer. (Courtesy of Carol Bennett.)

On June 6, 1917, a tornado swept across the heart of the city, causing heavy damage. There were 17 people injured, and damages from the storm totaled about $300,000. This postcard shows the damage on the northeast corner of Meachem and Webber Streets after the storm blew through.

The Barnum and Bailey Circus was unloading its train and had barely begun setting up tents when a tornado passed by Battle Creek. The circus was located near the Nichols and Shepard Threshing Machine factory on Marshall Street (now East Michigan Avenue). The circus tents opened for shows at 1:00 p.m. and 7:00 p.m.

Battle Creek, Mich., Private Grounds along Maple Street.

In 1870, Silas Pittee built a home at 238 Maple Street. In 1872, it was purchased by Samuel Bagley, a local tanner and dealer of leather goods. It was acquired by Carroll L. Post (brother of C. W. Post) in 1898, remodeled, and enlarged into a 42-room mansion. During World War I, it was rented by Walter Scott Butterfield (founder of the Butterfield Movie Theaters). In 1921, it was sold to Bernarr MacFadden and used as the International Health Resort. For many years, it was the largest house in Battle Creek.

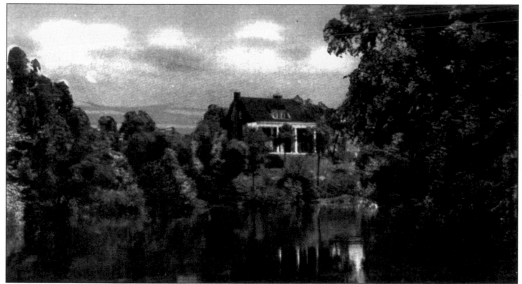

This home was built on West Michigan Avenue in 1906 by lawyer Burritt Hamilton. It was known as the "Lilacs" because of the extensive use of lilacs and roses on the grounds. The pillared porch faced south, toward the Kalamazoo River, until 1960 when the Kalamazoo River Diversion project moved the river approximately 200 yards to the south, leaving a marshy wetland. Hamilton specialized in corporate law.

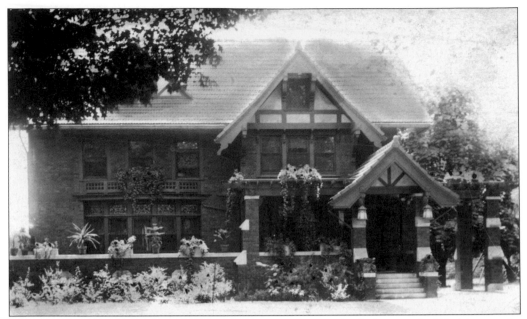

This arts and crafts–style residence at 276 Maple Street was built for Winford Robinson, the secretary-treasurer of the H. B. Sherman Manufacturing Company. In the second decade of the 20th century, it was purchased by Seirn B. Cole, a builder and contractor who moved from Detroit to build city hall in 1913. George R. Rich, who was founder of Rich Steel Products (see page 48), bought the house in 1917. In 1986, it was restored and converted into the Lamplighters Bed and Breakfast. It returned to a private residence in the 1990s.

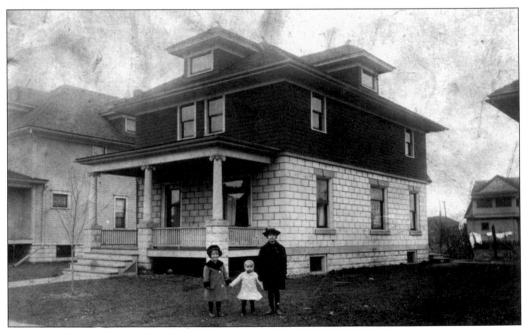

This house at 17 Wren Street was where coauthor Carol Bennett's father, Paul Linstead Jr. lived between 1915 and 1920. The girls in the image are his sisters, seen from left to right, Marion, Alberta, and Pauline Lindstead. (Courtesy of Carol Bennett.)

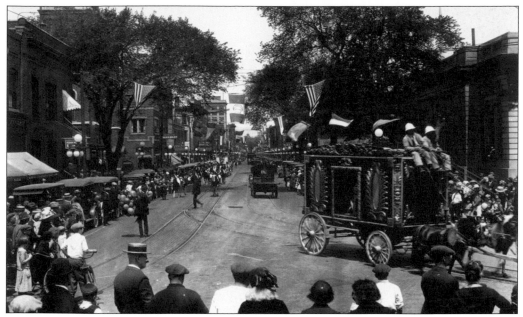

Before radio, movies, and television became popular, local citizens looked forward to visits by circuses and their parades through downtown, as shown in this postcard from the second decade of the 20th century. P. T. Barnum brought his circus to Battle Creek for the first time in 1877. On June 22, 1883, his circus brought Jumbo, the world's largest elephant to the city. (Courtesy of Carol Bennett.)

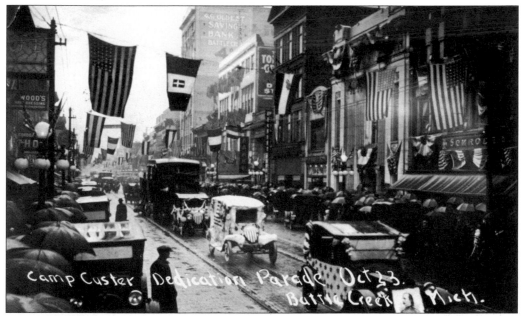

On a rainy October 23, 1917, a parade was held in downtown Battle Creek as part of the dedication festivities for Camp Custer (see page 75), the 10,000-acre cantonment built six miles west of the city as part of World War I preparations. This view is of the south side of Main Street (now West Michigan Avenue) looking toward the intersection with Jefferson Street (now Capital Avenue) from the center of the main block.

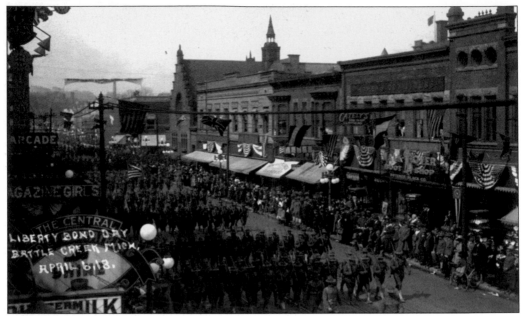

This Liberty Bond parade took place on April 6, 1918. The army had three major bond drives (bonds were sold to fund the military budget in World War I) over a 28-day period in 1918. The Michigan town that exceeded its financial quota was given an honor flag to fly over the city. This parade of the 337th Infantry on Main Street (now West Michigan Avenue) is looking at the north side of the street toward the intersection with McCamly Street.

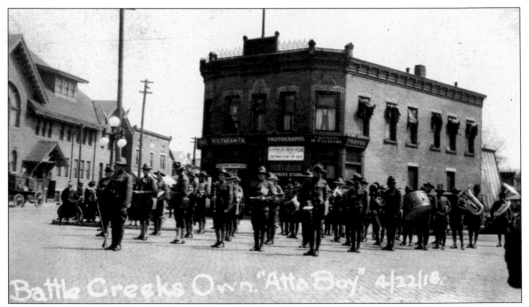

On April 22, 1918, this army band from Camp Custer performed at Monument Square (see pages 2 and 12) in front of French's Photography Studio on the southeast corner of Main Street and South Avenue. The First Methodist Episcopal Church is on the left. (Courtesy of Carol Bennett.)

Battle Creek celebrated the 100th anniversary of its founding in 1931. The largest parade in the city's history was held on October 5, 1931. The crowds at the conclusion of the parade are shown at the intersection of McCamly Street and West Michigan Avenue looking northwest on this postcard. Pictured are, from left to right, Wood's Furniture Store, the Regent Theater, and the Central National Bank.

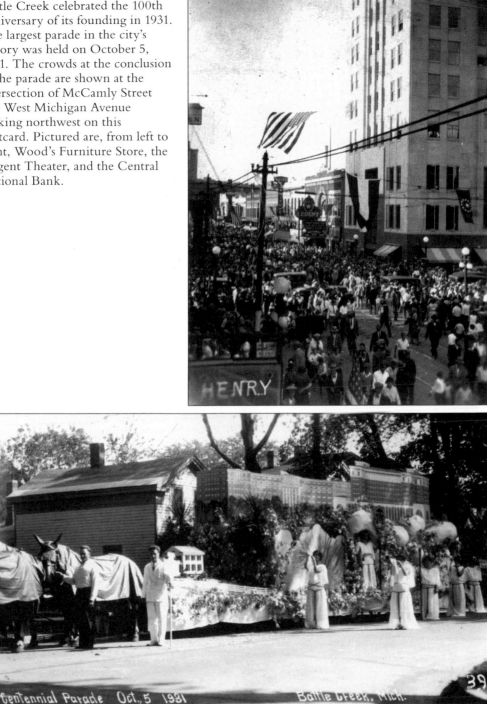

The 1931 Battle Creek Centennial Parade featured many extravagant floats. Many businesses tried to outdo their rivals. The Battle Creek Sanitarium had many displays and floats in the parade. This one features a replica of the San building with robed women heralding the public with trumpets.

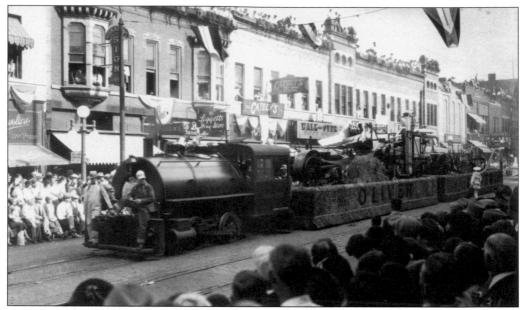

One of many participants in the 1931 Battle Creek Centennial Parade was the Oliver Factory Float. The view is of the north side of West Michigan Avenue near the McCamly Street Intersection. The small steam engine is pulling a display of threshing machines and farm equipment produced at the factory down the street using the city's streetcar tracks. This steam engine also appears on page 25.

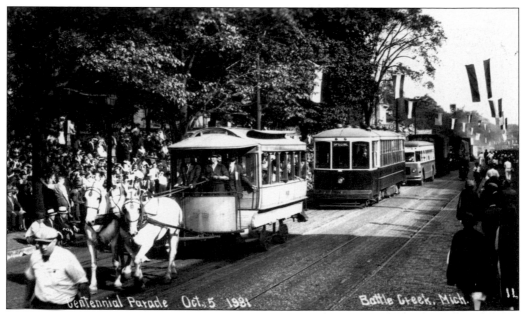

This postcard shows the Battle Creek Centennial Parade held on October 5, 1931, passing in front of McCamly Park on West Michigan Avenue, near Washington Avenue. The different forms of public transportation displayed show the progress made over the past 100 years, from horse-drawn streetcars to gas-powered buses.

The Seventh Day Adventist Church has a deep history connected to Battle Creek. This postcard shows the 63–65 North Wood Street home and Oakhill Cemetery tomb of Ellen and James White, early founders of the church. Many of Ellen White's writings were made in the upper bedroom of this house. In 1966, the house was purchased by the Adventist Historic Properties. In the 1990s, the area around the Whites' house was transformed into the Adventist Village, a four-block museum consisting of historic buildings related to church history.

As part of the United States' 150th birthday celebration, the Junior League of Battle Creek sponsored a re-creation of the "longest breakfast table in the world" in the summer of 1976. The event had been started in 1956 to recognize the 50th anniversary of the Kellogg Company. Since its reestablishment during the nation's bicentennial, it has become an annual event letting everyone know that Battle Creek is still one of the best-known cities of its size in the world.

www.arcadiapublishing.com

Discover books about the town where you grew up, the cities where your friends and families live, the town where your parents met, or even that retirement spot you've been dreaming about. Our Web site provides history lovers with exclusive deals, advanced notification about new titles, e-mail alerts of author events, and much more.

Arcadia Publishing, the leading local history publisher in the United States, is committed to making history accessible and meaningful through publishing books that celebrate and preserve the heritage of America's people and places. Consistent with our mission to preserve history on a local level, this book was printed in South Carolina on American-made paper and manufactured entirely in the United States.

This book carries the accredited Forest Stewardship Council (FSC) label and is printed on 100 percent FSC-certified paper. Products carrying the FSC label are independently certified to assure consumers that they come from forests that are managed to meet the social, economic, and ecological needs of present and future generations.

FSC
Mixed Sources
Product group from well-managed
forests and other controlled sources

Cert no. SW-COC-001530
www.fsc.org
© 1996 Forest Stewardship Council

Find Your Place in History.